# 4000 ALPHABET & LETTER MOTIFS

## A SOURCEBOOK

GRAHAM LESLIE McCALLUM

DEDICATION
In fond memory of my dog Lupy Lupus, who lay faithfully at my feet until I finished this book and then passed-on, aged 19.

ACKNOWLEDGEMENTS
The Master Author
The scribes of the past
Charlene McCallum Weber – for her invaluable assistance and artistic skill

First published 2009
for the publisher

B T Batsford
Anova Books
The Old Magistrates Court
1-0 Southcombe Street
London W14 0RA

Text and illustrations © Graham Leslie McCallum 2009
Volume © Anova Books Ltd 2009

ISBN 9780713490602

A CIP catalogue reference for this book is available from the British Library.

Printed in Malaysia for Imago Publishing Ltd

www.anovabooks.com

Distributed in the United States and Canada by Sterling Publishing Co.,
387 Park Avenue South, New York, NY 10016, USA.

# CONTENTS

# INTRODUCTION

## THE GENEALOGY OF LETTERING

There can be few images that we identify as readily as the letters that make up our Latin/Roman alphabet. They are as familiar to us as our mirrored reflections and as warmly recognizable as the features of those we love.

If you observe a family of several members, you will notice that siblings share similar features. This is because they share similar genes inherited from both their parents. Though not identical in appearance, these similar characteristics tie them together as kin. This is also true for the greater Roman alphabetic tribe, where even a casual eye can discern lettering clans and identify script families. This book, which is constructed as both a design sourcebook and instructional manual, group these alphabet families together for your instruction, convenience and inspiration. This extensive collection of historic alphabets are ordered chronologically so that the reader can follow the developmental timeline that leads them down through the millennia.

Our 26 letters are passed down from one human generation to the next. This is our bequeathed inheritance as readers, writers and calligraphers. Letters formulated 4000 years ago by people living in what is now the Sinai desert – and expanded upon in the Phoenician cities bordering the Levantine Sea – are our letters today. These precious heirlooms, first scratched onto wood and stone tablets and later transcribed by pen and ink onto papyrus and parchment, now emblazon our billboards with loud advertisements and sit quietly on our computer keyboards.

This book richly illustrates and explores this heritage all the way from our letters' initial Egyptian inspiration, through the seafaring hands of the innovative Phoenicians, whose galleys and ideas traversed the Mediterranean Sea, over to the ancient Greeks with their aesthetic sensibilities and onwards to our present handwriting and printed models. En route we investigate those practical Roman scribes, whose contributions chiselled into marble encapsulate the very classical idiom of a perfectly crafted letter. Not stopping in ancient Rome, but climbing the Alps, through Italy, we traverse the plains of Barbarian Europe on an alphabetical journey through the Pre-Romanesque era with its idiosyncratic inscriptions and manuscripts.

Using this book's timeline, we navigate across the English Channel to the home of the Celts where the art of writing reaches new heights in innovation and beauty. This manual draws from this alphabetical treasure chest. This Celtic family of lettering is tremendously popular with calligraphers today and I am sure they will be popular with this book's readers.

The art of writing leads the reader over the Irish Sea in an alphabetical coracle with Saint Columba to the realms of the Scots and Anglo-Saxons. In England, books such as the beautiful Lindisfarne Gospel were created by dedicated Christian monks. These scripts and letter-forms are still as inspirational today as they were then. Many of these exquisite books and manuscripts were taken by missionary monks to mainland Europe, and you will find that many of these alphabets still have modern applications.

No book on lettering would be complete without exploring the Gothic Age. The ogee arches and pointed cresting of cathedrals were duplicated in the writing of the day, now known as Black Letter. Seven hundred years on and we are still making use of Gothic lettering. Many calligraphers have found that their interest in lettering was sparked when they first saw Gothic lettering.

We in the 21st century are quite familiar with the Humanist lettering of the Renaissance. The reason for this is that the first printers of books looked back to Humanist lettering models for inspiration. (Interestingly enough, the Humanist scribes had themselves looked back to the Carolingian and early Roman lettering for their inspiration.) I hope an appreciation of lettering in this book will allow you to develop your own styles of writing and lettering.

Included in this compilation are a collection of modern alphabets by the author for your personal use. The latter half of this book comprehensively explores the individual 26 letters – the initials – in all their many forms and various strokes. There are nearly 9000 individual letters in this book (including those in the alphabets), with the accompanying CD holding an additional 3600 more, and an additional 30 full alphabets. The calligrapher, graphic artist, hobbyist and craftsperson will certainly find within this collection an alphabet or letter motif that will enhance their creativity.

It is my sincere hope that the reader will find pleasure at the sheer beauty of our scribal heritage, but also that the incredible inventiveness in form and shape of our alphabet will inspire the reader to pursue the art of writing, that they develop their own styles, and in so doing, pass the torch on and contribute to the future.

GRAHAM LESLIE MCCALLUM

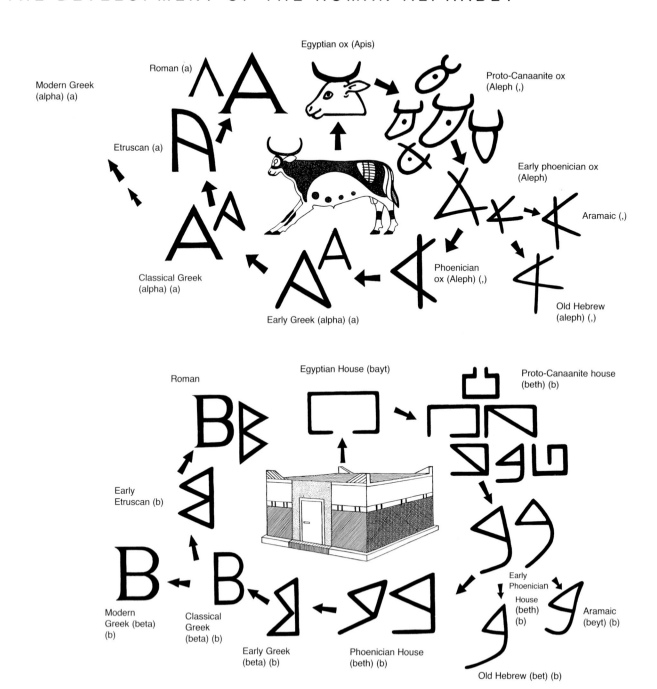

Modern Greek
(alpha) (a)

Roman (a)

Egyptian ox (Apis)

Proto-Canaanite ox
(Aleph (,)

Etruscan (a)

Early phoenician ox
(Aleph)

Aramaic (,)

Classical Greek
(alpha) (a)

Phoenician
ox (Aleph) (,)

Old Hebrew
(aleph) (,)

Early Greek (alpha) (a)

Roman

Egyptian House (bayt)

Proto-Canaanite house
(beth) (b)

Early
Etruscan (b)

Early
Phoenician
House
(beth)
(b)

Aramaic
(beyt) (b)

Modern
Greek (beta)
(b)

Classical
Greek
(beta) (b)

Early Greek
(beta) (b)

Phoenician House
(beth) (b)

Old Hebrew (bet) (b)

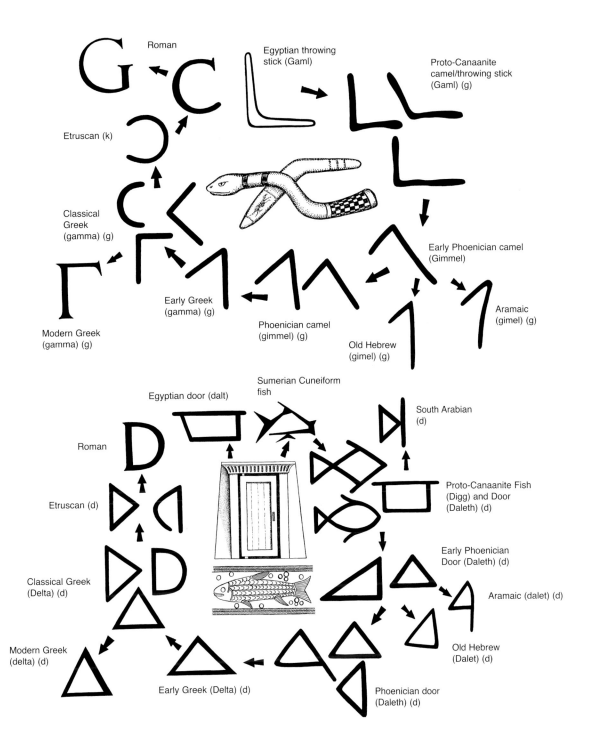

Roman

Egyptian throwing stick (Gaml)

Proto-Canaanite camel/throwing stick (Gaml) (g)

Etruscan (k)

Classical Greek (gamma) (g)

Early Phoenician camel (Gimmel)

Early Greek (gamma) (g)

Aramaic (gimel) (g)

Modern Greek (gamma) (g)

Phoenician camel (gimmel) (g)

Old Hebrew (gimel) (g)

Egyptian door (dalt)

Sumerian Cuneiform fish

South Arabian (d)

Roman

Etruscan (d)

Proto-Canaanite Fish (Digg) and Door (Daleth) (d)

Classical Greek (Delta) (d)

Early Phoenician Door (Daleth) (d)

Aramaic (dalet) (d)

Modern Greek (delta) (d)

Old Hebrew (Dalet) (d)

Early Greek (Delta) (d)

Phoenician door (Daleth) (d)

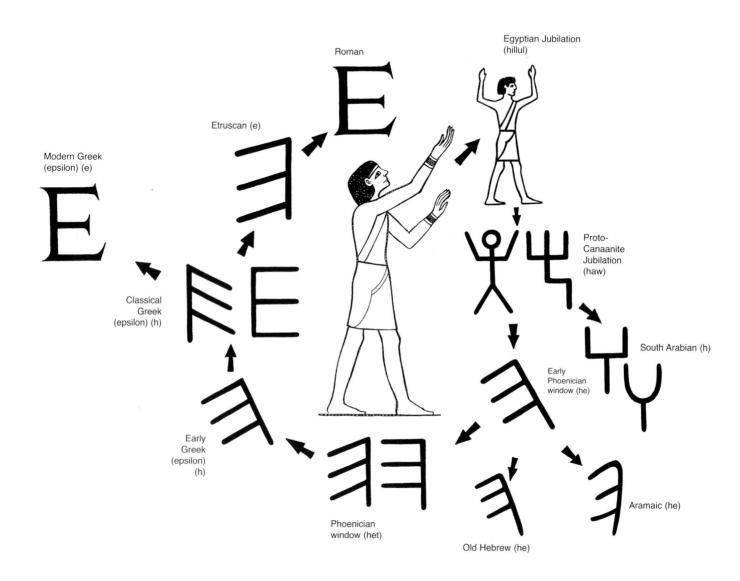

Modern Greek
(epsilon) (e)

Roman

Egyptian Jubilation
(hillul)

Etruscan (e)

Proto-
Canaanite
Jubilation
(haw)

Classical
Greek
(epsilon) (h)

Early
Phoenician
window (he)

South Arabian (h)

Early
Greek
(epsilon)
(h)

Aramaic (he)

Phoenician
window (het)

Old Hebrew (he)

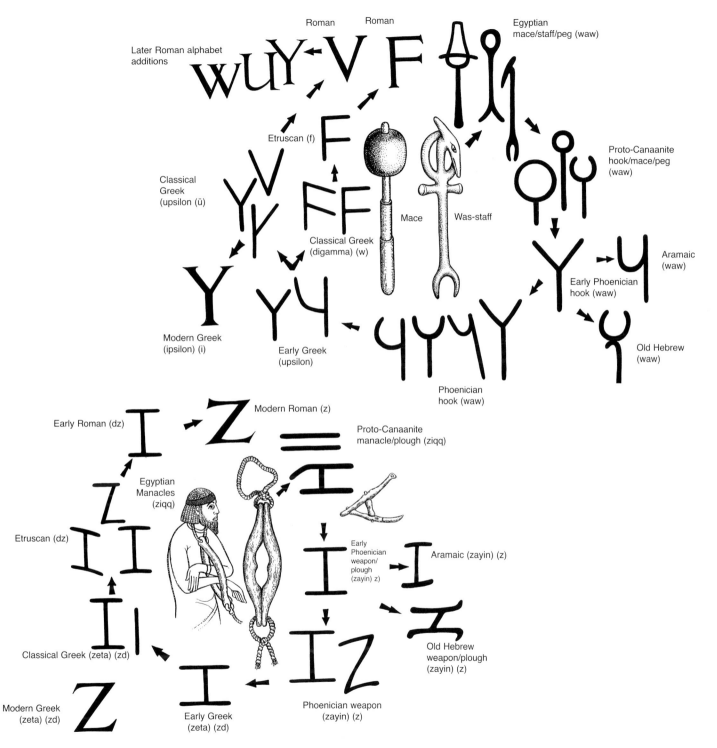

Later Roman alphabet
additions

Roman

Roman

Egyptian
mace/staff/peg (waw)

Etruscan (f)

Classical
Greek
(upsilon (ü))

Classical Greek
(digamma) (w)

Mace

Was-staff

Proto-Canaanite
hook/mace/peg
(waw)

Modern Greek
(ipsilon) (i)

Early Greek
(upsilon)

Early Phoenician
hook (waw)

Aramaic
(waw)

Old Hebrew
(waw)

Phoenician
hook (waw)

Early Roman (dz)

Modern Roman (z)

Proto-Canaanite
manacle/plough (ziqq)

Egyptian
Manacles
(ziqq)

Etruscan (dz)

Early
Phoenician
weapon/
plough
(zayin) z)

Aramaic (zayin) (z)

Classical Greek (zeta) (zd)

Old Hebrew
weapon/plough
(zayin) (z)

Modern Greek
(zeta) (zd)

Early Greek
(zeta) (zd)

Phoenician weapon
(zayin) (z)

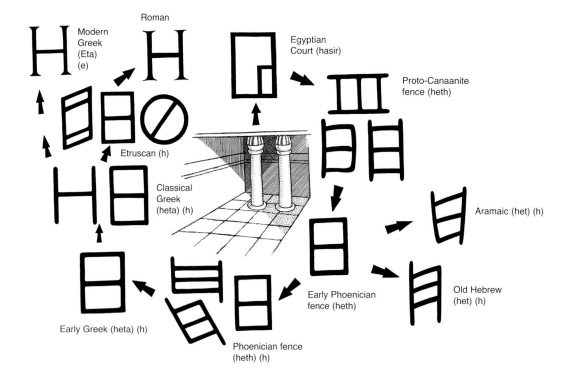

Roman

Modern Greek (Eta) (e)

Egyptian Court (hasir)

Proto-Canaanite fence (heth)

Etruscan (h)

Aramaic (het) (h)

Classical Greek (heta) (h)

Early Phoenician fence (heth)

Old Hebrew (het) (h)

Early Greek (heta) (h)

Phoenician fence (heth) (h)

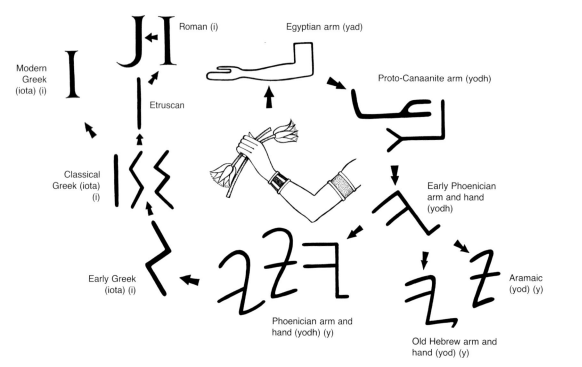

Roman (i)

Egyptian arm (yad)

Modern Greek (iota) (i)

Etruscan

Proto-Canaanite arm (yodh)

Classical Greek (iota) (i)

Early Phoenician arm and hand (yodh)

Early Greek (iota) (i)

Aramaic (yod) (y)

Phoenician arm and hand (yodh) (y)

Old Hebrew arm and hand (yod) (y)

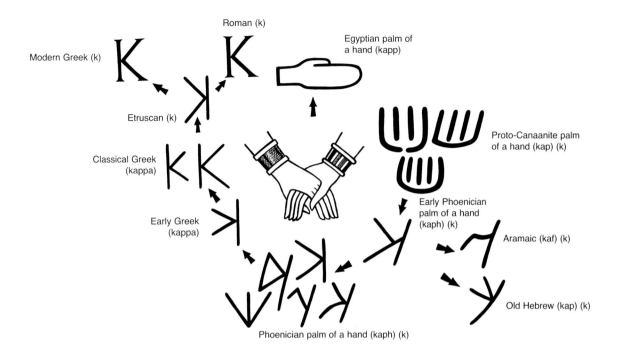

Roman (k)

Modern Greek (k)

Egyptian palm of
a hand (kapp)

Etruscan (k)

Proto-Canaanite palm
of a hand (kap) (k)

Classical Greek
(kappa)

Early Phoenician
palm of a hand
(kaph) (k)

Aramaic (kaf) (k)

Early Greek
(kappa)

Old Hebrew (kap) (k)

Phoenician palm of a hand (kaph) (k)

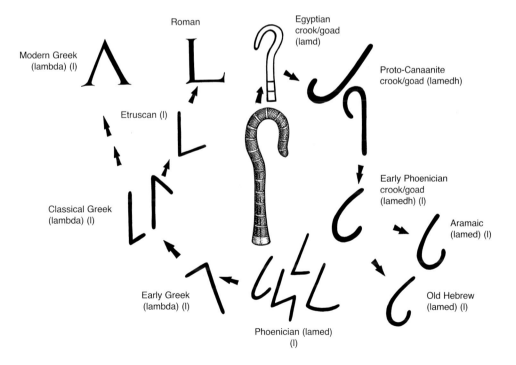

Roman

Egyptian
crook/goad
(lamd)

Modern Greek
(lambda) (l)

Proto-Canaanite
crook/goad (lamedh)

Etruscan (l)

Early Phoenician
crook/goad
(lamedh) (l)

Classical Greek
(lambda) (l)

Aramaic
(lamed) (l)

Early Greek
(lambda) (l)

Old Hebrew
(lamed) (l)

Phoenician (lamed)
(l)

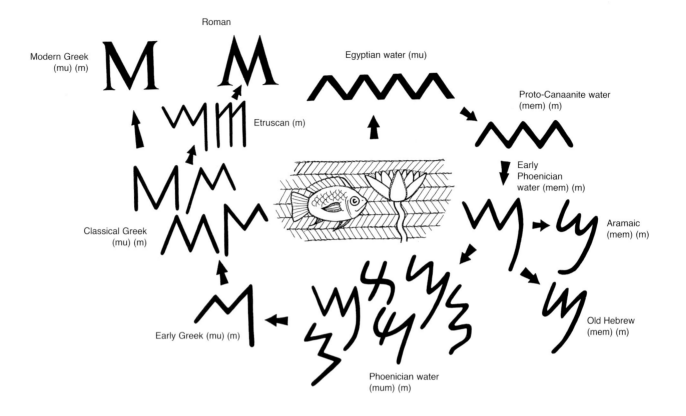

Roman

Modern Greek (mu) (m)

Egyptian water (mu)

Proto-Canaanite water (mem) (m)

Etruscan (m)

Early Phoenician water (mem) (m)

Classical Greek (mu) (m)

Aramaic (mem) (m)

Old Hebrew (mem) (m)

Early Greek (mu) (m)

Phoenician water (mum) (m)

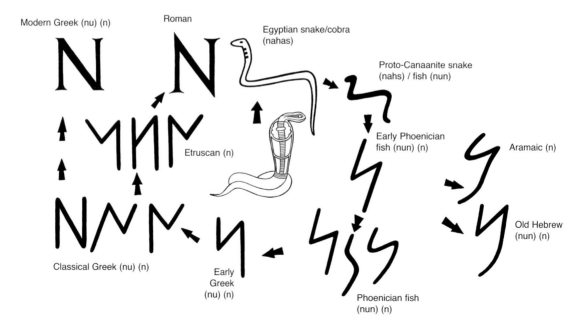

Modern Greek (nu) (n)

Roman

Egyptian snake/cobra (nahas)

Proto-Canaanite snake (nahs) / fish (nun)

Etruscan (n)

Early Phoenician fish (nun) (n)

Aramaic (n)

Classical Greek (nu) (n)

Early Greek (nu) (n)

Phoenician fish (nun) (n)

Old Hebrew (nun) (n)

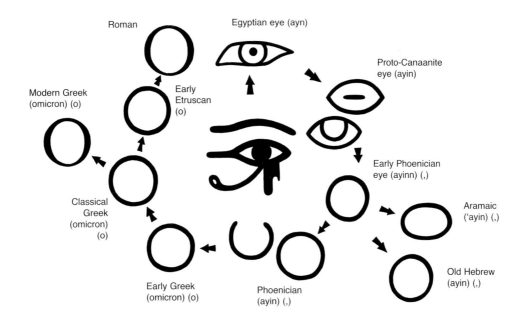

Roman

Egyptian eye (ayn)

Proto-Canaanite eye (ayin)

Modern Greek (omicron) (o)

Early Etruscan (o)

Classical Greek (omicron) (o)

Early Phoenician eye (ayinn) (,)

Aramaic ('ayin) (,)

Early Greek (omicron) (o)

Phoenician (ayin) (,)

Old Hebrew (ayin) (,)

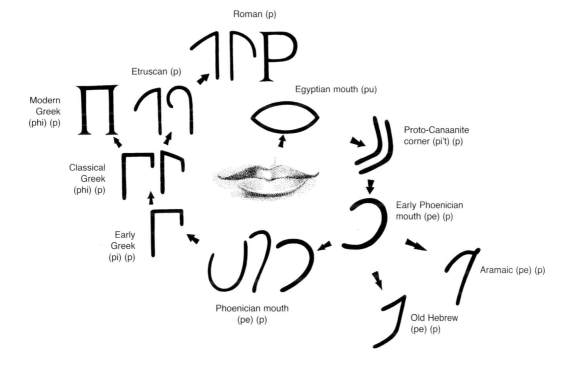

Roman (p)

Etruscan (p)

Egyptian mouth (pu)

Modern Greek (phi) (p)

Proto-Canaanite corner (pi't) (p)

Classical Greek (phi) (p)

Early Phoenician mouth (pe) (p)

Early Greek (pi) (p)

Aramaic (pe) (p)

Phoenician mouth (pe) (p)

Old Hebrew (pe) (p)

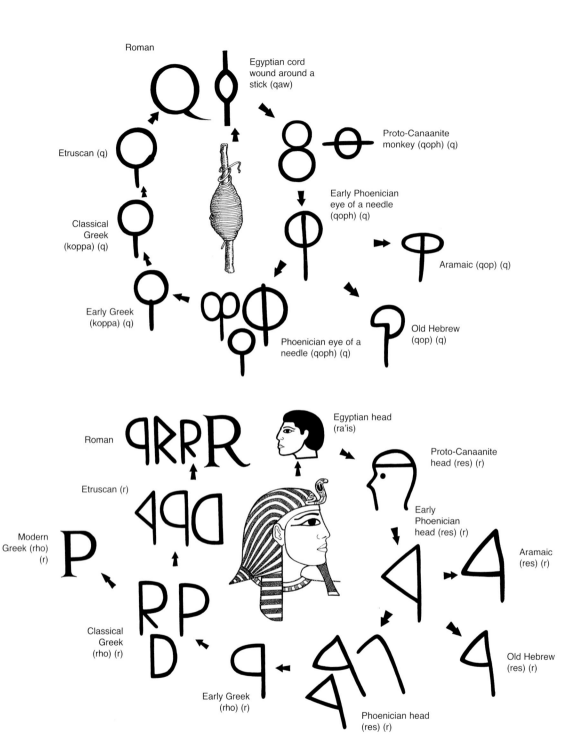

Roman

Egyptian cord wound around a stick (qaw)

Etruscan (q)

Proto-Canaanite monkey (qoph) (q)

Early Phoenician eye of a needle (qoph) (q)

Classical Greek (koppa) (q)

Aramaic (qop) (q)

Early Greek (koppa) (q)

Old Hebrew (qop) (q)

Phoenician eye of a needle (qoph) (q)

Roman

Egyptian head (ra'is)

Etruscan (r)

Proto-Canaanite head (res) (r)

Modern Greek (rho) (r)

Early Phoenician head (res) (r)

Aramaic (res) (r)

Classical Greek (rho) (r)

Early Greek (rho) (r)

Old Hebrew (res) (r)

Phoenician head (res) (r)

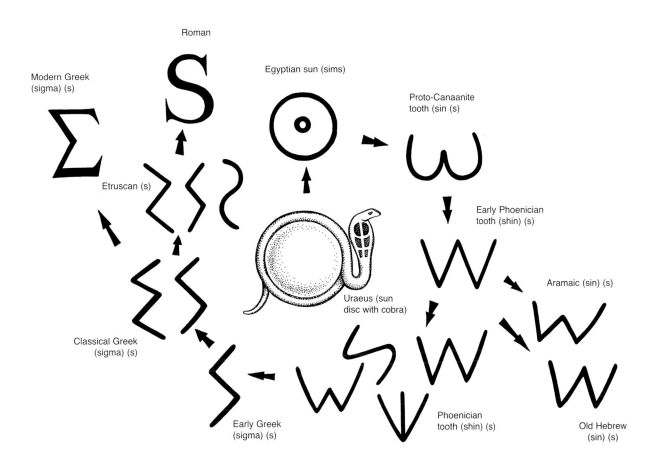

Modern Greek
(sigma) (s)

Roman

Egyptian sun (sims)

Proto-Canaanite
tooth (sin (s)

Etruscan (s)

Early Phoenician
tooth (shin) (s)

Aramaic (sin) (s)

Classical Greek
(sigma) (s)

Uraeus (sun
disc with cobra)

Early Greek
(sigma) (s)

Phoenician
tooth (shin) (s)

Old Hebrew
(sin) (s)

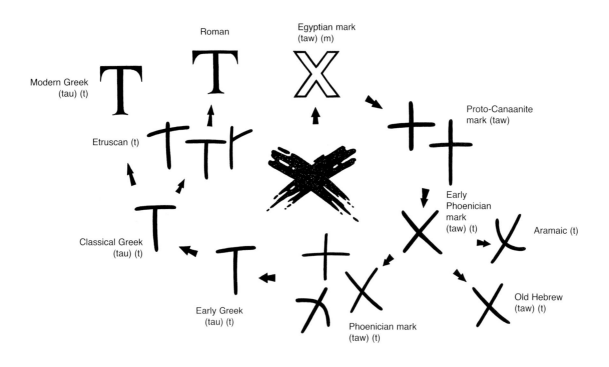

Roman

Modern Greek (tau) (t)

Etruscan (t)

Classical Greek (tau) (t)

Early Greek (tau) (t)

Egyptian mark (taw) (m)

Proto-Canaanite mark (taw)

Early Phoenician mark (taw) (t)

Aramaic (t)

Old Hebrew (taw) (t)

Phoenician mark (taw) (t)

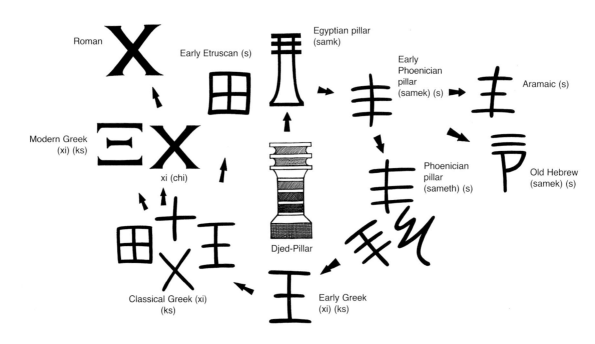

Roman

Early Etruscan (s)

Egyptian pillar (samk)

Early Phoenician pillar (samek) (s)

Aramaic (s)

Modern Greek (xi) (ks)

xi (chi)

Djed-Pillar

Phoenician pillar (sameth) (s)

Old Hebrew (samek) (s)

Classical Greek (xi) (ks)

Early Greek (xi) (ks)

The early Roman alphabet and the Latin written language did not make use of all of our present 26 letters. The letters J, K, U, W and Y are all later additions, created when the Germanic languages were written down, and the letter Z was a Roman retrieval from the ancient Etruscans, used for writing down Greek names.

In this book, all the letters that appear after the diamond symbol have been originated by the author in the style and form of the existing scripted alphabet so as to complete a modern and fully functional alphabet; or, as substitutes to letters that are vague or unfamiliar to the modern eye.

All letters that appear after a circle symbol are inscriptional variations to the alphabet. You may wish to use these variations as letter substitutes, or you may wish to give your lettering an emphasis or quality that a particular letter possesses.

# OLD ROMAN CURSIVE ALPHABETS

This cursive script was retrieved from a 1st-century AD papyrus manuscript. It was used by regular Roman scribes to convey everyday messages onto ordinary scrolls. Documents written in this script (executed with a pen and ink, unlike printed letters and built-up letters like versals) were executed at great speed. This script has simplicity of form and brevity of stroke, giving the impression of immediacy and ease. The letters B, G, Q and R are vague to the modern eye, but their variants may be substituted for greater clarity.

This unique and historic Old Roman cursive script from the 1st century was retrieved from a ten-line fragment called the 'Fragment de Bellis Macedonicis'. It is clearly influenced by the Old Roman cursive script yet anticipates the Uncial script of the 4th century onwards. There are more curved pen-strokes than its ancestor, and with rounder forms. This script has the appearance of having ascenders (pen strokes that rise above the top line in miniscule scripts) and descenders (pen strokes that fall below the base line in miniscule scripts).

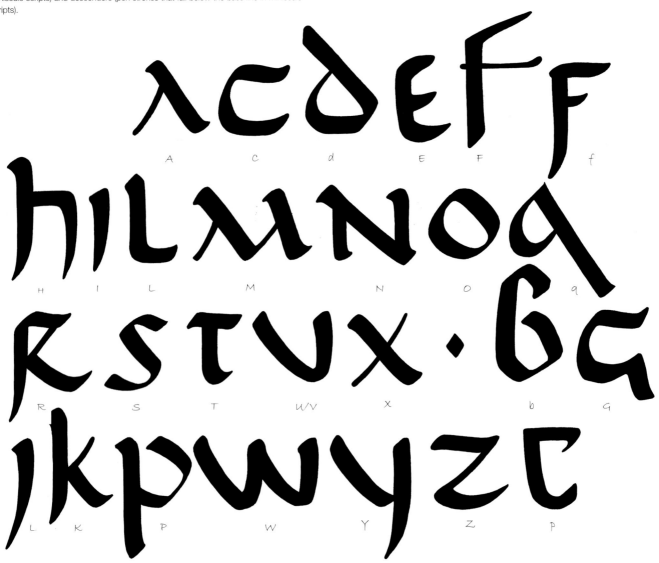

This influential 4th-century New Roman cursive documentary miniscule (lower case alphabets) developed gradually from Old Roman cursive. The Uncial, Half-Uncial and Carolingian styles of the 7th and 8th centuries adopted many of this script's letter-forms. These styles in turn influenced the scripts of the 9th and 10th centuries – such as the Merovingian, Visigothic and Island styles; and later still, the Humanistic scripts.

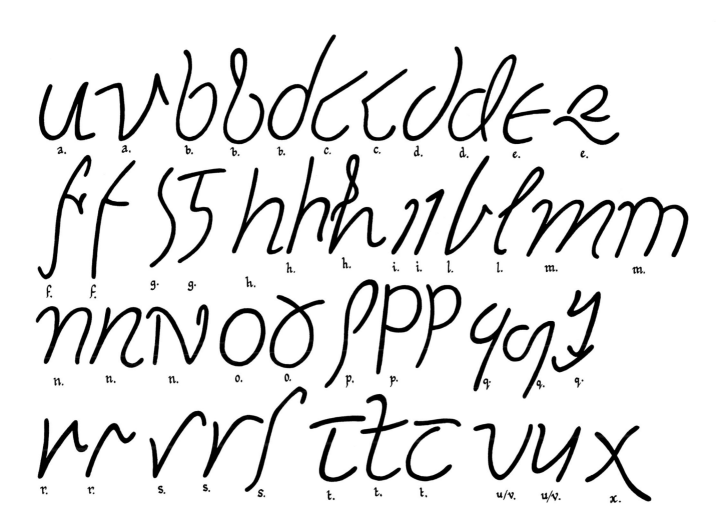

ABCDEFG
HILMNOP
QRSTVXYZ·
JKUW·
BHMNQUSY

Many of the signs and adverts, as well as the daubed graffiti from the city of Pompeii, were brushed onto walls in this most rustic of scripts. Its function dictated an economy of brush-strokes coupled with speedy execution. This alphabet is a composite of letters taken from 1st century BC and AD inscriptions.

This rustic alphabet, taken from a dedicatory inscription in stone (Dedication to Romulus from 126 AD), is individualistic and unusual in that its rustic quality is not befitting a monument in some ways. To the modern eye, it has an oriental flavour and would no doubt suit a Chinese theme.

A B C D E F G

H I L M N O P

Q R S T V · Z

J K U W X Y

# ABCDEFGHI
# LMNOPQRS
# TVX·JKUWZ

# ·ΛΔDEFGM
# NOPQT

This bold rustic script has several unique, yet beautiful letter forms (its letters f, l, and p anticipate the later Half Uncial script). They vary from the sweeping to the contained, from the bold to the refined, from the curved to the angular and from the classic to the idiosyncratic.

ABCDEFG
HILMNO
PQRSTVX·
JKUWYZ

This 4th-century Majuscule (upper case) script is wonderfully bold and graphically modern. Its wave-like horizontal and diagonal strokes impart an expansive and flowing quality to the script. Its eclectic ancestry is betrayed by its composition of both Rustic and Classic Square Capital forms.

# ROMAN INSCRIPTIONAL SQUARE CAPITALS

This elegant alphabet is from the inscriptions on Trajan's Arch in Rome (114 AD). The crisp sharp lines to the letters and the wedge-like serifs are partly the result of the scribe's stone chisel. This gives these letters a monumental formality and a timeless beauty – most befitting a grandiose arch. Scribes and calligraphers agree that this most classic of alphabets is one of the most influential. Letters H, J, K, U, W, Y and Z are additions from later centuries.

# ABCD
# EFGHI
# JKLM

# NOPQ
# RSTU
# VWX
# YZ

# ABCDEFGHI LMNOPRST VX·JKQUWY Z

Strength and legibility are the characteristics of this classical inscription. It is relatively condensed in comparison to the inscription on Trajan's Arch, and emboldened (thickened pen-strokes), thus making it a very practical and user-friendly lettering. The letter G and B are comparatively rustic to their companions.

# ABCDEFG HILMNOP QRSTVX· JKUWYZ

St. Lizier, France is the home of this remarkable alphabet taken from an inscription in stone and dated to the year 100 BC. Its slender and well-formed strokes give this lettering elegance and formality. This dignity is further enhanced by the feminine curled serifs, which are unusual for their time.

The unusual pointed terminals and curled serifs imbue this alphabet with an attractive decorative effect. The letter-forms are classical (pertaining to the formal letter-forms found on Trajan's Arch) in origin and elegant. This script was retrieved from an inscription in stone from the Catacombs of San Callisto, Rome (366–384 AD).

ABCDEFG
HILMNOP
QRSTV·
JKUWXYZ

The Christian Epitaph of Constantia (393 AD) is the source of this idiosyncratic alphabet. Although far from the classical model, this alphabet is not without its charm. Note the unusual letters F, K and L. This lettering anticipates the scripts of the Romanesque period.

AACCDEF
HIKLMNOO
PQRSSTVX·
YBGJUWZ

These regular letter-forms, found on an inscription in stone from Rome (440–461 AD), convey a refined quality. The fish-tail serifs add a further decorative touch, making this formal alphabet current and functional.

# ABCDEFG
# HILMNOP
# QRSTVX·
# JKUWYZ

ABCDEFG
HIKLMNO
PQRSTUXY·
JVWZ

This script, taken from an early 8th-century English Psalter, has a marvellous fullness and relaxed rusticity. The sweeping cross-strokes and serifs are almost brush-like.

# ABCDEFGH
# ILMNOPQR
# STUX·
# JKUWYZ

In this alphabet the brushstroke-like cross-bars and serifs, as well as the sweeping diagonals, are interestingly contrasted with the very straight (sometimes thin, sometimes thick) vertical strokes. This script was taken from the Utrecht Psalter (820–840 AD).

ABCDEGIL
MNOPQR
STVX·HJ
KUWYZ

Epitaph inscriptions are a wonderful source for interesting alphabets. This highly inventive and individualistic lettering is from a Christian epitaph dated to the year 587 AD.

# ABCDEFGH
# ILMNOPQR
# STVϘ·
# JKUWZ

This inscription is taken from a 7th-century stone tablet in Arles, France. Many of the letter-forms appear to have Insular (Irish and Anglo-Saxon) characteristics.

# ABCDEFGHI
# LMNOPQRS
# TV·JKUWYZ

The bold letter strokes in this Majuscule (upper-case alphabet) imparts strength, while the large wedge-serifs firmly anchor this alphabet onto the base line. This capital was taken from an epitaph to the Irish monk Cumian, in Bobbio, Italy (740–744 AD).

ABCDEFGHI
LMNOPQR
STUXY.
JKWZ

The economic letter construction and the disconnected nature of the letter strokes gives this 4th-century uncial script a simplicity and rusticity unlike other uncial scripts.

The Codex Bobiensis (a 5th-century North African work) is the source for this beautiful uncial script. Bold diagonal strokes predominate but do not overwhelm other angled strokes. The fluid curves of varying degrees, create inner spaces (called counters) of varying shapes – triangles, lozenges and rounded squares.

ABCDEFG
hILMNOP
qRSTUX·
JKVWYZ

By using the minimum of bold letter-strokes and by using fully rounded letter-forms, a 6th-century Italian scribe was able to give his script great strength and commanding presence.

ABCDEFG
hILMNOP
QRSTLI·VI
WXYZk

The beautifully rounded letter-forms, coupled with the even and steady stroke-curves, give this 6th-century script (taken from an Italian gospel) a friendly open face. The angular strokes of the letter D is in marked contrast to the rounded forms of other letters.

ABCDEFG
HILMNOP
QRSTUX·
JKUWYZ

The well-known Vespasian Psalter, created in the 8th century, is the source for this accomplished Majuscule (upper case) script. The scribe must change the angle of his pen within the execution of a single letter. Note the pleasant wave-like serifs of this script's terminals. Also, note the drags made with the edge of the scribe's broad nib in letters such as L and X.

ABCDE

GHILMN

OPQRST

UX·JKVWYZ

A modern version of an uncial script.

ABCDEFG
HIJKLMNO
PQRSTUV
WXYZ

A modern version of an uncial script.

ABCDEF
GHIKLMN
OPQRSTU
VUWXYZ

A modern version of an uncial) script.

ABCDEFG
hIJKLMNO
PQRSTUV
WXYZ

abcdeƒ

ꌗhilmno

pqnrꞇuz

uxꞏjkuuy

This script (509–510 AD) is an early example of the Half Uncial style of writing. Its ancestor is not the Uncial style but rather Old Roman cursive (meaning running). Letters are well-formed with fully rounded form. The result is a friendly, warm and engaging script without pretension. It looks quite current because early 14th-century printers looked to older forms for inspiration, such as the Carolingian styles whose ancestors were Roman Cursive, Uncial and Half Uncial and we still use these fonts. Note the Half Uncial letter g and f.

# abcdefg

## hilmnopg

## rstux.

## jkvwz

The Insular (island) influences in this most famous of Uncial scripts is very evident in letters such as the b, l, and n. The source for this Irish half uncial script is the 'Book of Kells' (800 AD). Letters are well anchored by their large flat serifed feet, but balanced by their upper, slightly diagonal terminals. Letters are written in bold strokes, are well-rounded and formed (bowls) and feature generous counters (inner spaces). This is a difficult script to execute because it requires pen manipulation, especially on the serifs. Remember to leave generous interstices (spaces between letters) and words, to harmoniously balance this script.

# abcdefzhi
# lmnopqr
# ſtu x
# jkvuwyz

This workman-like Half Uncial is from the 9th-century Codex Aesinas Latinus. Bold letter strokes transcribe pentagon-shaped letters and counters, giving this script its angular features (almost anticipating the Gothic style). Note the letter s – for greater current legibility, you may wish to curve this letter slightly into the shape we know today.

The English Caedmon Manuscript, written in 1000 AD, is the source for this balanced Anglo-Saxon Half Uncial script. The vertical strokes to the letters b, f, p and s that taper gently towards their bottoms are a marked feature of this script. These transect the base line to form fine points. Base terminals are semi-serifed with flick-ups. The letter g and s are not familiar to the modern eye and may be substituted for legibility purposes with the originated letters provided.

abcdefg
f.

hilmnopr
r.

rtuy·jksg
s.                                    s.    g.

qvuuxz
q.

abcdefg

hilmnopq

nrtux · q

jkvuwyz

The letters at reduced scale with annotations: g (top right), q (right), r (below n), s (below r), g (right of x)

This Irish Half Uncial script has as its source the Annals of Inisfallen, written in 1092 AD. The letter a, d, q and x are idiosyncratic and when coupled with heavy wedge-shaped upper serifs, we have a unique insular script.

**A B C D E F T H I L M**

c.          g.          l.    m.

**N O O R S T U X · H**

n.   o.   p.   q.          v.   x.   h.   s.

**A B E F N B S N V H O**

s.       b.   e.   f.   n.   b.   s.   n.   v.   h.   d.

**H · J K G W Y Z**

n.       j.   k.   g.       w.       y.       z.

Rectangular execution is the marked feature of this Irish Versal (decorative) alphabet, taken from the Book of Kells of 800 AD. Many of these letters are idiosyncratic, giving these letters marvellous originality. Letter variations add further creative exuberance.

These beautiful Anglo-Saxon Versals have strong but restrained insular qualities. The varying heights of the letters lend further interest and charm.

ΛΛΛα BbCC
DdEEhIHm
NOOPpRRR
STTUUV·FG
JLLqSWXZ

There are marked similarities between this Irish/Anglo-Saxon lettering and that of the Visigoths. Although many letter-forms are of conventional construction, several are unique, such as the letters R, L, U, and Q. The scribe added several decorative features to his lettering – double cross-bars, fish-tail serifs and spiralled terminals.

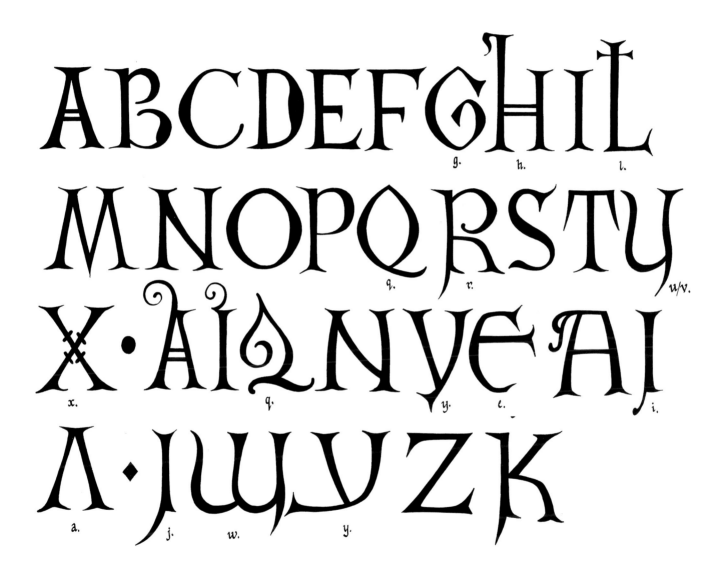

Versal (decorative) capitals can be based not only on Roman square capitals but also on other scripts – in this case, Uncial. This unique lettering from the Codex Bobiensis was created in North Africa in the 5th century. These capital letters have unusual stroke-like diagonal serifs that have the effect of creating a repeat-pattern. Although the letters are composed of curves, there are definite points along their courses where the strokes take a new directional angle.

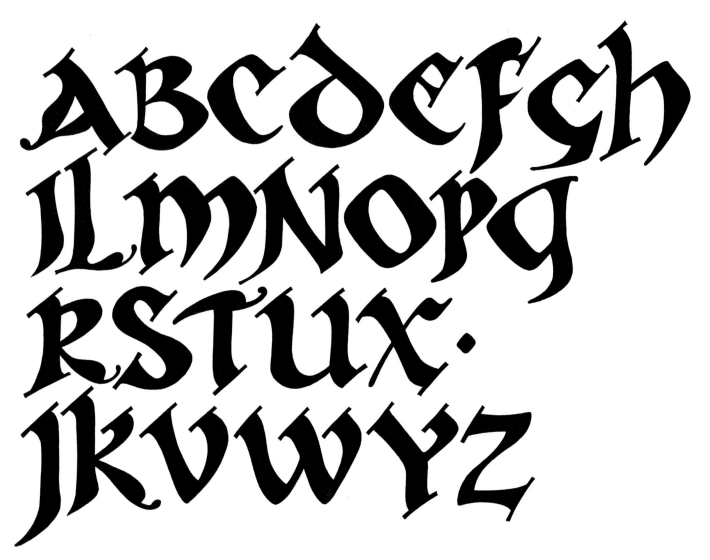

This is the Medieval Versal (decorative) lettering that so many calligraphers know and admire. Strokes are bold and swollen along their lengths as is the general custom with this Versal letter. The serifs are charmingly wishbone-like, some of them extending (both horizontally and vertically) along the full length of the letters.

A B C D E F G
H I J K L M N O
P Q R S T U V
W X Y Z

A brilliant and unusual take on Versal (decorative) capitals, this even-line alphabet has a
linear construction. It is almost a lesson in itself on how to compose a Versal letter.

ABCDEF
GHIJKLMN
OPQRSTU
VWXYZ

Classic Roman capitals are the basis for this exquisite lettering. Letter-strokes broaden subtly towards their terminals and are neatly capped-off with restrained serifs.

# A B C D E F G H
# I J K L M N O P
# Q R S T U V W
# X Y Z

This is a modern version of an Uncial Versal alphabet with full but restrained forms and serifs.

A collection of 350 Versal (decorative) capitals taken from Pre-Romanesque, Romanesque, Uncial, Half Uncial, Carolingian and Gothic manuscripts.

EEEEEEEEEEEE

FFFFFFFFFFF

FFFA

GGGGGGGGGGG

NbHHHHHHK

HHHHHHHH

A collection of Versal (decorative) capitals taken from Pre-Romanesque, Romanesque, Uncial, Half Uncial, Carolingian and Gothic manuscripts (see also opposite page).

A collection of Versal (decorative) capitals taken from Pre-Romanesque, Romanesque, Uncial, Half Uncial, Carolingian and Gothic manuscripts (see also opposite page).

A collection of Versal (decorative) capitals taken from Pre-Romanesque, Romanesque, Uncial, Half Uncial, Carolingian and Gothic manuscripts (see also opposite page).

# ABCDEF
# GHILMMNO
# PQRSTU·JK
# VUUXYYZ

The letter-forms to this 8th-century alphabet are based on the standard Uncial, but whereas the original was executed with a broad-nibbed pen, these letters have to be first constructed with pen lines and then their interiors flooded with ink (called built-up lettering). The letter-forms are full-bodied and pleasingly even and translate perfectly into the modern idiom.

This 8th-century Carolingian Majuscule (upper case) alphabet is based completely on the Uncial script and is visually satisfying and particularly beautiful. Its letter-forms are pleasingly formed of even curves and harmoniously balanced with slightly dished (concave) vertical and diagonal pen-strokes.

ABCDEFG
hILMNOP
QRSTUX·
JKVWYZ

There is a Runic (a North European writing that predates the introduction of the Roman alphabet) flavour to these Anglo-Saxon capitals from the Book of Nunnaminster (9th century). Most letter-strokes are quite straight, with very few curves, giving these letters a geometric quality. This is further enhanced by triangle-shaped serifs.

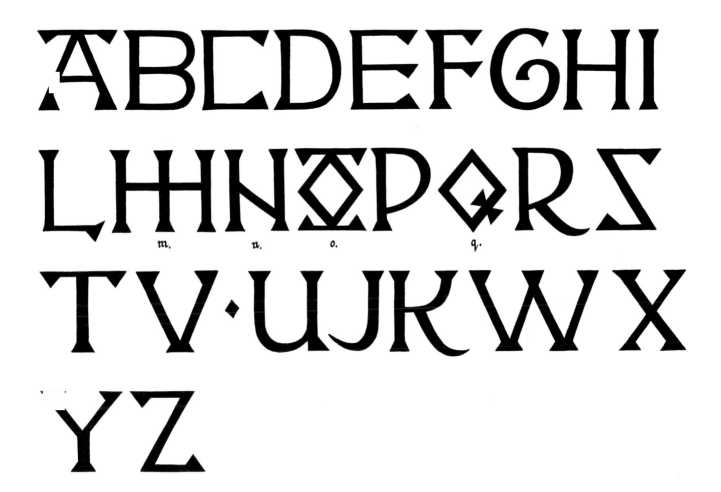

Ease of execution is a prominent feature of this Anglo-Saxon Majuscule (upper case alphabet). Letters are attractively formed, with even and logical pen-strokes and sensible serifing.

ΛA BCC DE
FGhILLMN
OPQRSTUX
YW·JKVZ
·AGWEE

a b c d d e e f

g h i l m n o p q

r f a u x z · k z

p · j k s t v u u x y z

Miniscule (lower case) scripts came to prominence in the Romanesque period across Europe. They were more economical in space and they allowed the scribe greater ease in execution. Visigothic Miniscule (seen here) arose in the 7th century and lasted until the 13th century. Note the unusual letter-forms for the letters q, s, t, x and z, as well as the open-form letter a. Nib angle is held at a shallower 130 degrees to the base line on pen-strokes and even less on serifs.

Insular Miniscule (lower case) scripts from Ireland and England first appear in the 7th century and were used until the 12th century. This example from the Corpus Irish Gospel (12th century) is particularly beautiful and has great presence. The regular pattern-of-stroke created by the letters h, i, l, m, n, and u are pleasingly balanced by the angled, though full-bodied letters b, d, o, p and q.

abcdefg

*d.*  *f.*  *g.*

hilmnopqr

*r.*

rtux·g j

*s.*  *t.*

kvuuyz

# abcdefghi
# lmnopqr
# ſtuvx·jk
# suuyzg

g.

o.

p.

s.

t.

Just like in a human family, a script is very often the result of many of its letters carrying similar features. This is true for this Irish script taken from the Stowe Missal (around 750 AD). The letters a, b, c, d, e, g, o, q, t and v all possess a similar diagonal stroke that gives this miniscule (lower-case alphabet) its unique character. This effect is amplified by the regular and bold vertical pen-strokes and the consistently penned wedge-shaped serifs.

# aubcdefg
## hilmnopyrſ
### τuyy· gjkqs
#### uuxz

a. f. g. r. s. t. v.

The many pen-stroke angles to this 10th-century Anglo-Saxon Miniscule (lower-case alphabet) make this script interesting to a calligrapher. You could say what is consistent is the inconsistency. Note the open letter a, and the feature letters f and r.

# abcdefgh ylmnopq rstux· kvvwyz

The Beneventan Miniscule (lower-case alphabet) is an Italian scripted style that developed in the 8th century and lasted until the 16th century. This style is characterised by the unique form of the letters a, e, g and t and has distinct Half Uncial ancestry. The form of the letter g influenced the latter Humanistic Scripts of the Renaissance, as well as modern printing fonts. It is very beautiful, with fine consistency of letter stroke and form. Note the unique, but lovely letter t in this 1038–1055 alphabet.

ccbcddeſʒhilmnn
opqrrſſтuxүv.
шzjkɾt

There are many calligraphic elements to this French Merovingian (Luxueil) Miniscule (lower-case alphabet) from the 7th century. Vertical pen-strokes taper down from club-like upper terminals to fine points, giving this script a relatively top-heavy look. There are several unique and interesting letter-forms such as the letters f, o, r, s and t.

abcdefg
hilmnopq
rſstux·
jkvuuyz

Flowing pen-strokes, full sweeping curves and restrained serifs make this 9th-century Italian
Carolingian Miniscule (lower-case alphabet) exceptionally beautiful, yet fully functional.

# abcdefgh

# ilmnopqrs

# tux·jkvwuy

This pleasing Carolingian Miniscule (lower-case alphabet) of unknown provenance, has a slightly condensed letter-form, with pen-stroke-curves that are slightly angled. Ascending stroke terminals are nicely capped-off with flat serifs. The outstanding letter in this script is the letter g with its unique and inventive form.

This late Carolingian Miniscule (lower-case alphabet) from the 10th century approaches the standard closely. Well-formed letters with user-friendly pen strokes and serifs makes this a workman's script for everyday use.

abcdefʒhil

mnopqrſt

ux · jksvuuyz ·

g2a

abcdefghil

mnopqrꝛſs

r.   r.   s.   s.

tux

·jkvwyz

The fuller letter-forms and the softer angles to this Gothic Miniscule (lower-case alphabet), give us a clue to its Carolingian ancestry. Note also the Carolingian serifing. This 12th-century French miniscule is therefore a Proto-Gothic script.

The source for this Proto-Gothic script is a 12th-century English manuscript. The angled strokes are so attributable to Gothic scripts. However, note the retention of Carolingian serifs and the fuller counters (inner spaces) from the past.

abcddefghil

mnopqrꝛꞓsꞇ
r.    s.    s.

ux·jkvwwyz

# abcdefghilm

# nopqrsſtur.

s.    s.                                          x.

# rdipdz.

v.

# jkvwwyz

v.

This beautiful, though formal, script is from an English
13th-century manuscript. Its angled strokes are
harmoniously balanced with curved pen-stokes such as in
letters b, g, o, x and p. The ascending strokes of letters b,
d, h and I swell pleasantly outwards like trumpets towards
flat-topped serifs. Any top-heaviness is balanced off by the
anchoring that the flat lower serifs afford.

A most beautiful Gothic Miniscule (lower-case alphabet) from 13th-century England with pointed apexes and more round angled base strokes. The relatively generous inner spaces to the letters give this script a welcoming face. Ascenders are capped with traditional Gothic angled serifs, while descenders and base strokes sport flick-ups.

abcdefghijlm

nopqzrsʃtuv

xyʒ· kw

# abcdefghilmn
# opqrstux·jkv
# wyz

x.

This English Gothic script is quite remarkable and praiseworthy for the regularity and precision of its forms and strokes. The inner spaces to the letters are just a little broader than are the vertical pen-strokes. Ascender terminals and base terminals are meticulously finished-off flatly. The source for this script is the 13th-century Luttrell Psalter.

This attractive and formal alphabet with its economic construction and formal regularity was sourced from a 14th-century inscription in Belgium. What appears to be left-sloping diagonals are in fact the broad stroke beginnings of the right-sloping diagonals. The inner-space counters are the same width as those of vertical pen-strokes, giving this miniscule (lower case) script a condensed (compressed horizontally) look.

abcdefghijk
lmnopqrstu
vwxyz

This most well-known and popular of Gothic scripts is known to calligraphers as 'Old English'. This style of Gothic is also known as Broken Gothic (pen strokes are discontinuous and unconnected). It possesses a decorative quality thanks to curled fishtail serifs. Regular pen-strokes of even construction add a further rhythmic effect.

abcdefghijk

lmnopqrst

uvwxyz

abcdefghij

klmnopqrsſ

tuvyzʒ

a. d. e. f. g. h.

r. s. s.

t. z. z.

The late Medieval Age produced many decorative Gothic Miniscules (lower-case alphabets), such as this Dutch 14th-century inscriptional alphabet. Despite all the many different serifs in this script (tapered points, fishtails, wishbones, split strokes, angled serifs and curls) the letter-forms are down-the-centre regular and ordered – indeed so regular that many letters are confusingly similar and the script loses a level of legibility.

Well-defined letter-forms and retrained decoration makes this late Medieval Fraktur Gothic Miniscule (lower-case alphabet) most attractive. Letters such as the a, b, d, g, o, p and q, with their large inner-space counters, give visual relief to the more ordered and condensed letters such as the c, e, m, n, and u. Straight pen-strokes are balanced-off with interesting swash-like curves, and several letters such as the d, v and w have charming flame-like terminals. Note the unique German letter for double s.

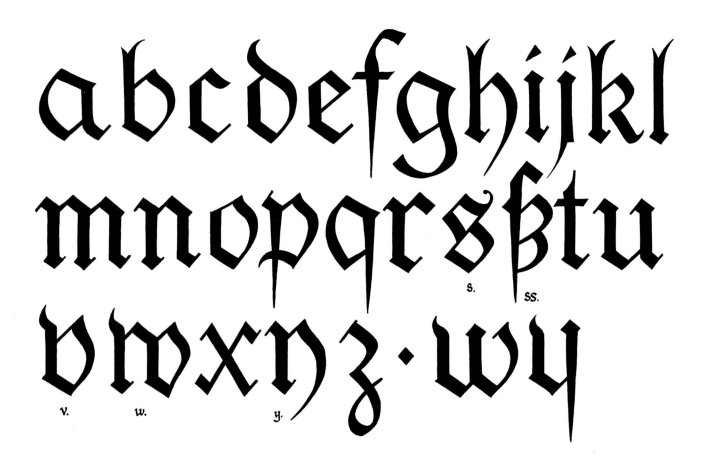

abcdefghil

mnopqrsftu

uuxz· jkvy

·dↄↄↄpⱴ

This 13th-century English Gothic script predates the appearance of the Gothic Documentary Hands of the 15th century. It is workman-like in execution, suiting its function perfectly, but without any aesthetic loss. This scribe appears to have had access to Carolingian manuscripts. Note the rotunda (curving-up or hook-like) base stroke terminals.

# abcddefg
a.
# hilmnopqr
# ʃstux·jkv
s. s.
# wyz

The overriding feature of this lovely Italian 15th-century Documentary Hand is the hexagram-shaped letter-forms and the six-sided counter shapes. The letters are full and the angles softly curved. Letters are well grounded by flat serifed feet, with ascending strokes broadening-out to flat upper serifs.

abcdefghilm

nopqz ſtuy

x·jkrswyz

*r.*  *s*  *v.*

*x.*

The pen-strokes to this 15th-century 'Bastarde' Documentary Hand appear to dance across the page, creating a lively flame-like effect. Pen-strokes are simple and quick to execute, with aesthetic curves.

# A B C D E F G
# H I J K L M N
# O P Q R S T
# U V V W X Y Z

The popularity of this decorative English Medieval lettering is ongoing. You may use the capital form or combine it with its miniscule (lower case) form found in the previous chapter. As far as High Medieval lettering goes, this script retains relative legibility. It invites the creative to experiment with the length and exaggeration of the swashes (wave and whip-like pen-strokes), and with the serifs and dental/ hairline decoration too. These letters work well as initials, for headings or for verse introductions.

ABCDEFGH
IJKLMNOP
QRSTUVW
XYZ

This is a simplified version of the more elaborate 'Old English' capital letter. The result is a script quicker to execute, with greater legibility and with a less cluttered appearance. The horizontal swashes give this script the appearance of banks of sea-waves.

This is an attractive modified Gothic Majuscule (upper-case alphabet). The straight and curved strokes of different angles, decorative-dentals, swashes, and diamond inclusions make this letter appear to dance before your eyes.

# ABCDDEFFG

# HIJKLMNO

# PQRSTUV

# WXYYYZ

All the sweeping curves, swashes, and full-formed letters to this script make this Black Letter (Gothic Textura) quite delightful. Notice the pleasing sickle-like starting pen-stroke of letters such as the B, N, R, U and W, and the playful flicked tails of letters K, L , Q, R and Z.

ABCDEFGH

IJKLMNO

PQRSTUU

WXYZ

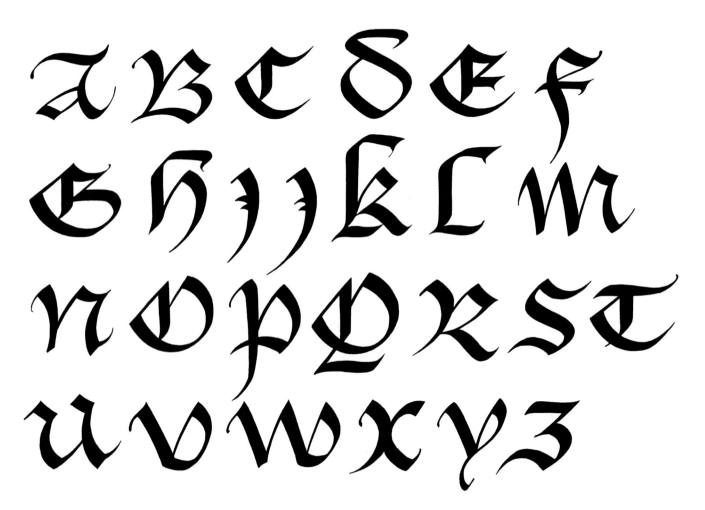

A sickle-stroke Gothic capital with pleasing construction, and sporting several unique and
interesting letter-forms such as the letter A, D, Q and W.

This delightful Gothic versal (decorative lettering), based on the Uncial script, is pleasingly decorative but retains its legibility. Letter-forms are full-bodied, even stretched a little horizontally, and decorated with wish-bone serifs and Gothic points.

A B C D E F G
H I J K L M N
O P Q R S T
U V W X Y Z

ABCDE
FGHILM
NOPQR
STUV
JKUW
8Z

Broad and full letter-forms and perfect curves are the delightful features of this very accomplished Gothic Versal (decroative lettering). Serifs are long slash-like strokes, many of them running or exceeding the full length of the letters.

# ABCDEFGHIJ KLMNOPQR STUVWXYZ

A strong and uncompromising modern version of a Gothic Majuscule (upper-case alphabet).

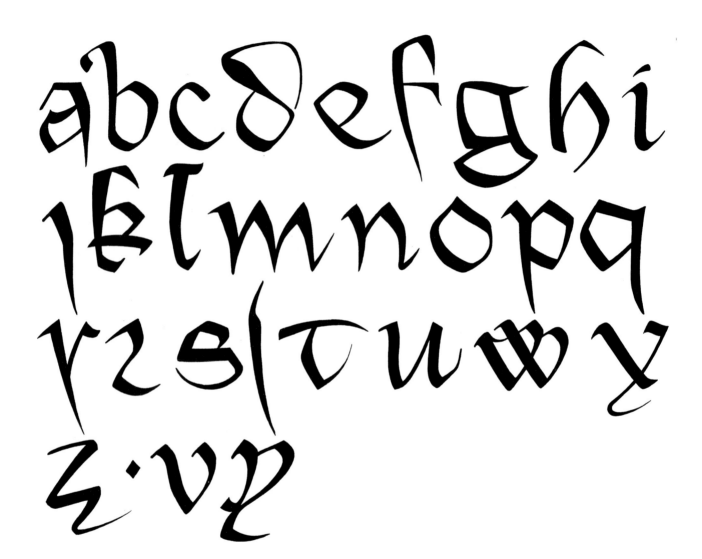

The bold pen-strokes give this Gothic cursive (meaning running hand) tremendous life and movement. This cursive script really gives an indication to this 13th-century scribe's personality – one of energy. The letter d is a masterpiece in construction.

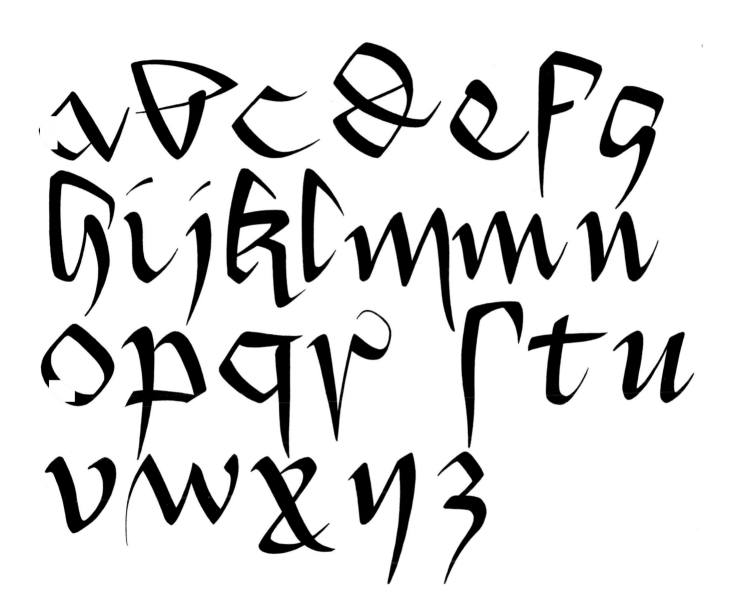

The sheer exuberance and dynamism of this Anglicana Miniscule (lower-case alphabet) is amazing. Pen strokes sweep from right to left and up and down, giving this script the appearance of swift execution.

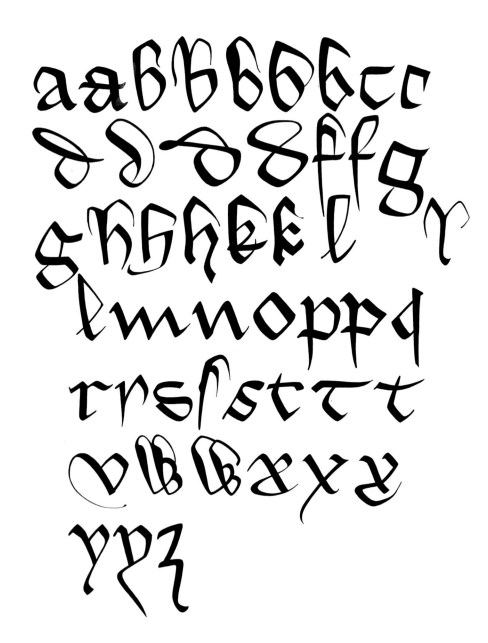

A compilation of Anglicana letters from various manuscripts that demonstrates the tremendous inventiveness of this style.

You can see from this 14th-century cursive (meaning running) script that letter-forms are reverting back to 8th- and 9th-century Carolingian models, yet anticipating the Humanist scripts of the 15th century.

abcdefghi
lmnopqrsſ
tuxyз·jku

abcdefghi
lmnopqrsſ
tuvy·ks
wyʒ

A French 15th-century Gothic cursive (meaning running).

This is an attractive German version of a Gothic cursive (meaning running), possessing confident letter-forms and economical pen-strokes. Notice how many of this scripts letters can be written without lifting the pen from the writing surface.

abcdefghi
lmnopqrfs
tuxyz·jkv

abcdefghi
klmnopqrſ
stuvwxyz·
ſz

This is an elegant English version of a Gothic cursive (meaning running).

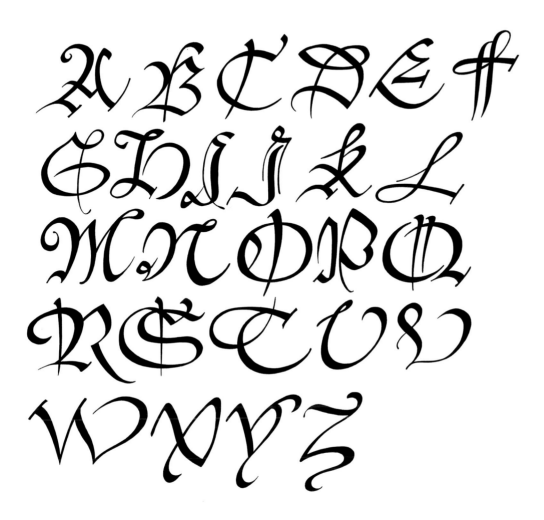

Inventive lettering and pen-stroke confidence give this 'Bastarde Capitals' (Secretary Hand) alphabet great presence. However, the execution is complicated and legibility reduced.

Full-bodied forms of inventive construction imbue this 15th-century English cursive (meaning running) capital with aesthetic delight.

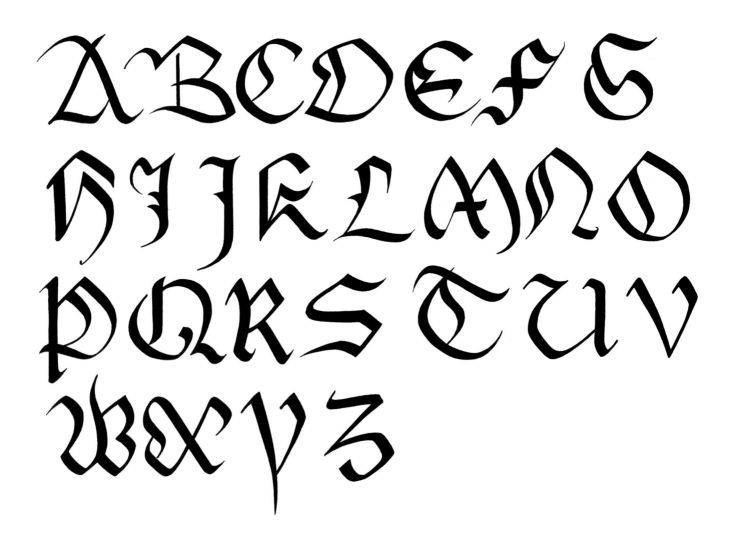

abcdefghi
lmnopqrsſt
uvx·jkwyz
s

The source for this script is a 14th-century Italian manuscript, and although it is 500 years old, it looks modern and fresh. The reason for this is that the first printers based many of their printing fonts on these Humanist scripts, and these have come down to us. It displays full-rounded letter-forms, even and ordered construction, and restrained ascender and descender stroke serifs. The letter g stands out with its angular construction, revealing the influence of Gothic cursive (meaning running). The scribe allows himself a small indulgence in giving his letter e a fly-away cross-bar.

# abcdefg
# hijklmn
# opqrstu
# vwxyz

This script shows great ease of construction, yet retains an aesthetic delight. This is not achieved by added decoration – rather, the beauty resides within the elegantly restrained and fully rounded forms. This lettering is in the Italic mode (leaning ever so slightly to the right), another functional consideration, as italicized writing is easier to execute.

This attractive upper-case script possesses fine legibility and classic letter-forms. It is easy and quick to execute and a favourite workman's script amongst calligraphers. Serifs are composed of bar-like strokes.

ABCDEFG
HIJKLMNO
PQRSTUV
WXYZ

# ABCDEFGH
# IJKLMNOP
# QRSTUVW
# XYZ

Cross-over pen strokes as in the letters A, D, E, F, H, P, and R give this Humanist capital script a decorative effect and purpose. This is evident in letters H, J, M, N, P, R and Y – where a writer is required to lift his pen after the vertical stroke to create the left-curling base serif.

Curled and clubbed serifs immediately places this eclectic Humanistic Majuscule (upper-case alphabet) in the decorative fold. It was created in the 14th century in Italy by the scribe Gabriel Altadell. There are Uncial elements present in letters D, E and T.

ABCDEFGH
ILMNOPQ
RSTV·JKU
WXYZ

# ABCDEFGH
# IJKLMNOP
# QRSTUVW
# XYZ

The letter-forms of these Humanist capitals are firmly based in the classical idiom.
This majuscule (upper-case alphabet) looks clean, crisp and current.

# abcdefghij
# klmnopqr
# stuvwxyz

The letter-forms in this attractive, partly decorative script approaches the Humanistic script standard quite closely. However, the long horizontal pen strokes in letters g, j and y break the model. When coupled with the banded upper stroke additions in letters m, n, r, u, v, w and y, we have a script with its own identity.

# ABCDEFG
# HIJKLMN
# OPQRSTU
# VWXYZ

This alphabet of capitals is paired with the previous miniscule (lower-case) script (see page 111).

abcdefghij
klmnopqr
stuvwxyz.
hlptvw

The letter-forms to this 16th-century script are slightly
condensed and pointed, as would a true cursive where the
fast-ascending pen-stroke sweeps up and bounces sharply
back down from the top line. You can see this action in the
letters b, h, m, n and p.

# abcdefghijk
# lmnopqrstu
# vwxyz

This handsome script has masculine square-like features. Serifs and ascending diagonals are stroke-like and thin, contrasting pleasantly with the thick descending strokes.

ABCDEFG
HIJKLMN
OPQRSTU
VWXYZ

A compilation alphabet of decorative italicized capitals.

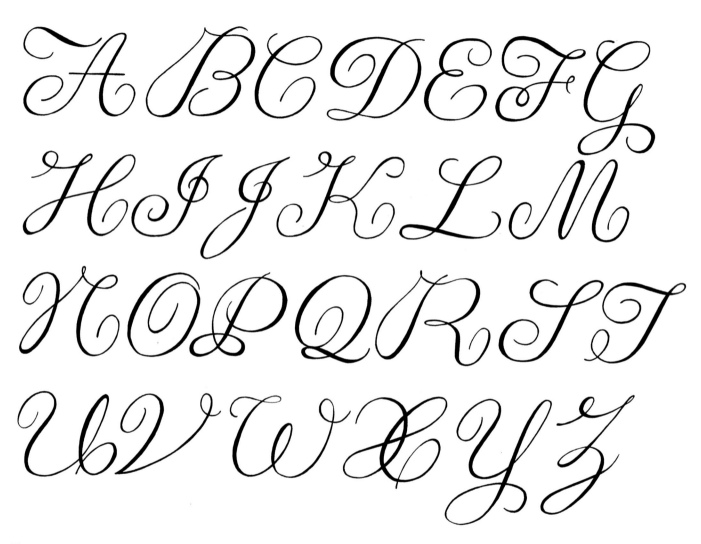

These well-known capitals were inspired by Copperplate (primarily a printed flourished letter) and the Humanist scripts. English Round Hand makes use of shading (the use of thin and thick strokes). English Round Hand is the standard and model used for the past two hundred years to teach handwriting to Western children.

# abcdefghij klmnopqrr sstuvwxyz

A lower-case script that is fully cursive (meaning running) with complete ligatures (strokes that connect letters) with full-forms and round flowing pen strokes.

abcdefgh

ijklmnopq

rsstuvw

xyz

This is a semi-cursive English Round Hand with warmly familiar pen-strokes and forms.

ABCDEF
GHIJKL
MNQPR
STUVW
XYZ

'Paperclip' alphabet designed by
Graham Leslie McCallum

# ABCEFG
# HIJKLMN
# OPQRSTU
# VWXYZ

'Wishbone' alphabet designed by Graham Leslie McCallum.

ABCDEFG
HIJKMNNO
PQRSTUV
WXYZ

'Whiplash' alphabet designed by Graham Leslie McCallum.

# ABCDEFG
# HJJKLMNO
# PQRSTUV
# WXYZ

'Heart 2 Heart' alphabet designed by Graham Leslie McCallum.

ABCDEFGH
IJKLMNO
PQRSTUV
WXYZ

Flick Flack' alphabet designed by Graham Leslie McCallum.

ABCDEFabcd

GHIJKLefghi

MNOPQjklm

RSTUVnopq

WXYZrstu

VVWXYZ

'Catwalk' alphabet designed by Graham Leslie McCallum.

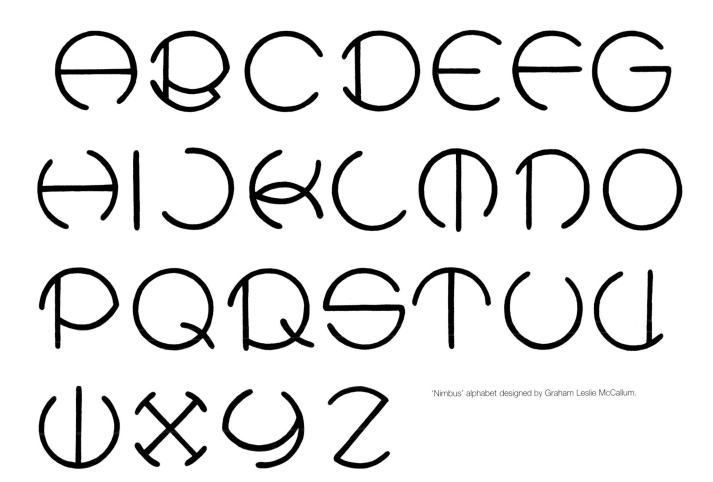

'Nimbus' alphabet designed by Graham Leslie McCallum.

ABCDEFG
HIJKLMN
OPQRSTU
VWXZ

'Cyber' alphabet designed by Graham Leslie McCallum.

# INITIALS

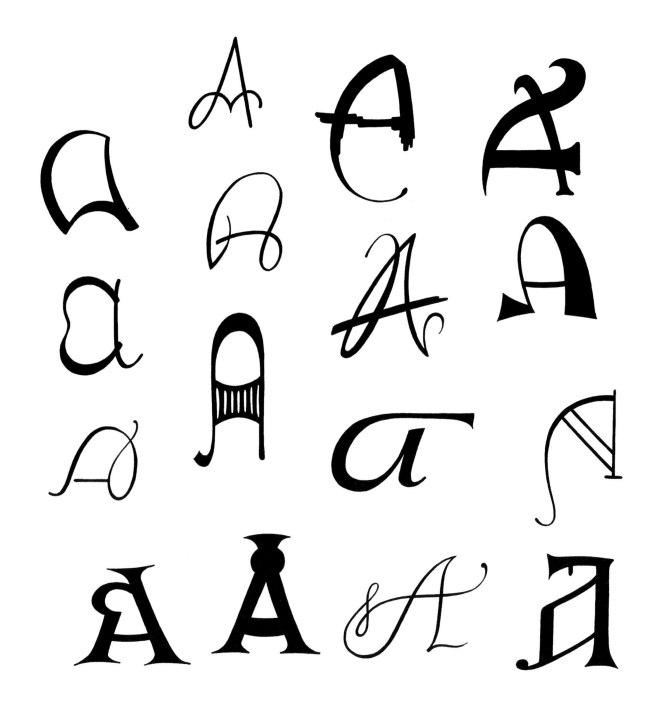

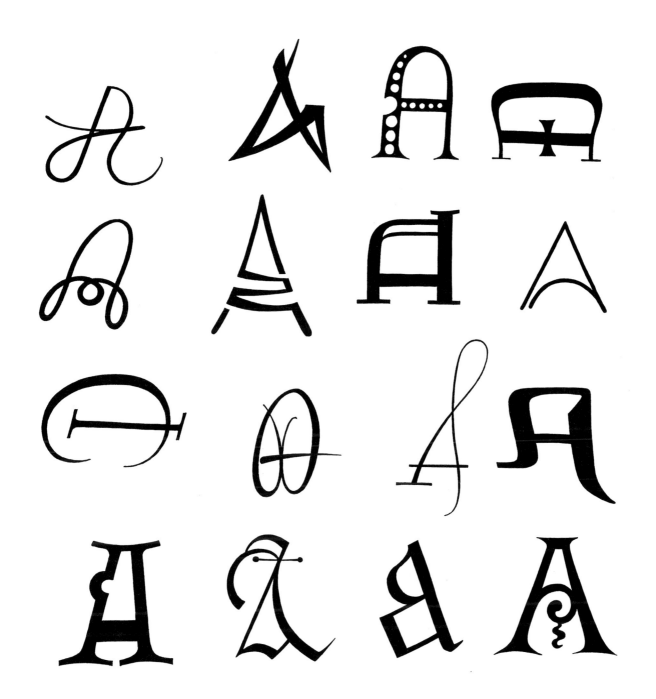

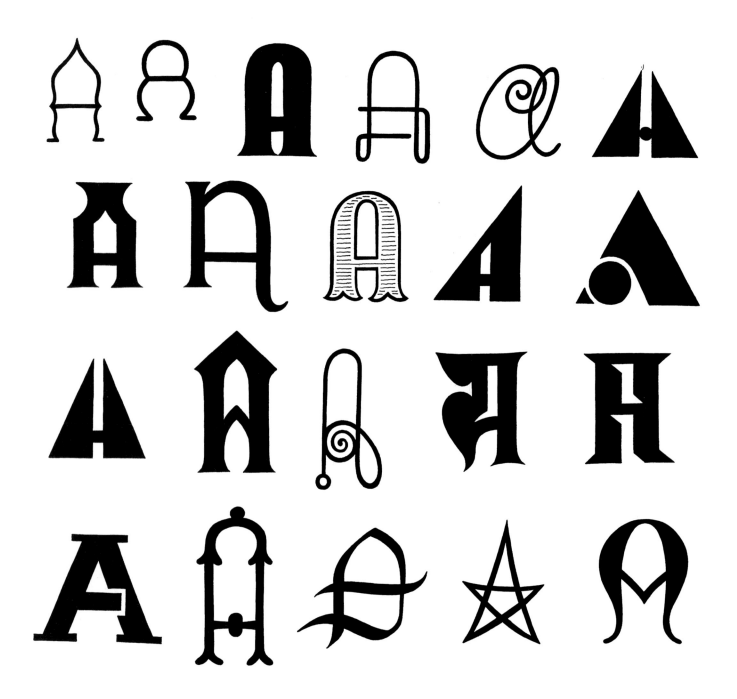

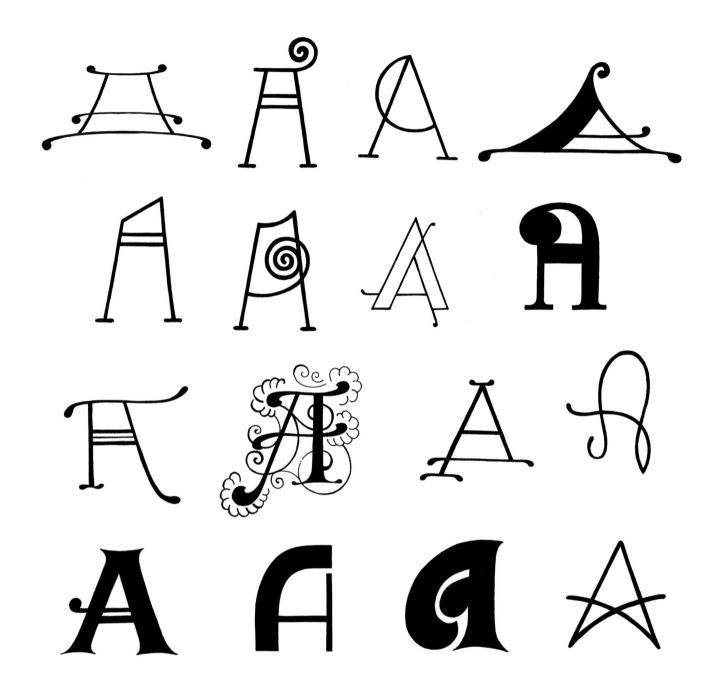

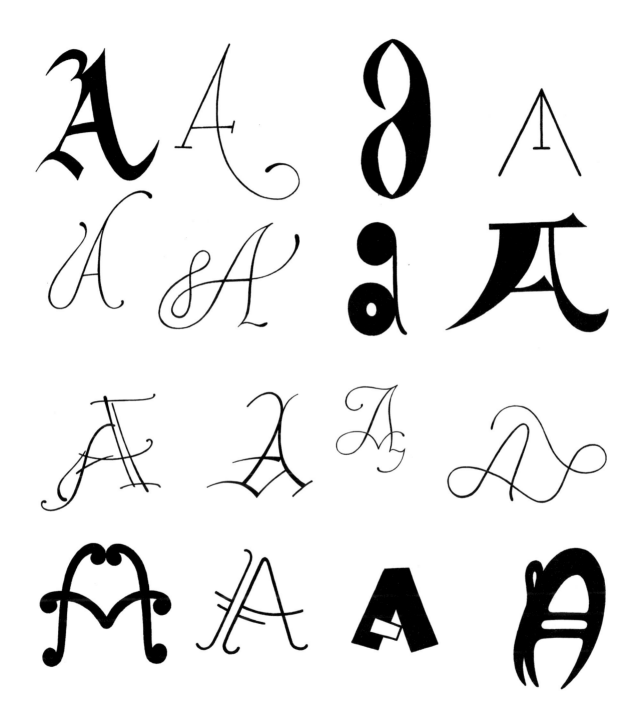

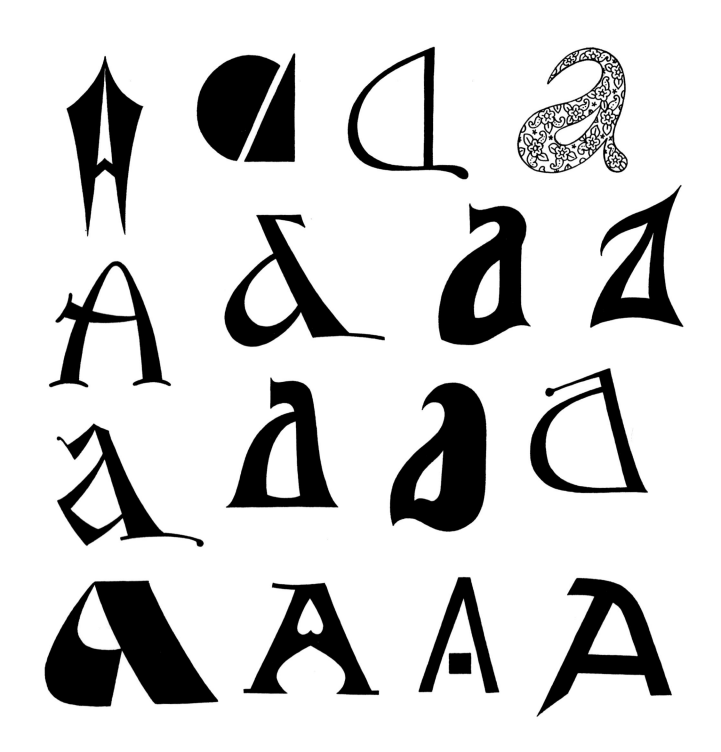

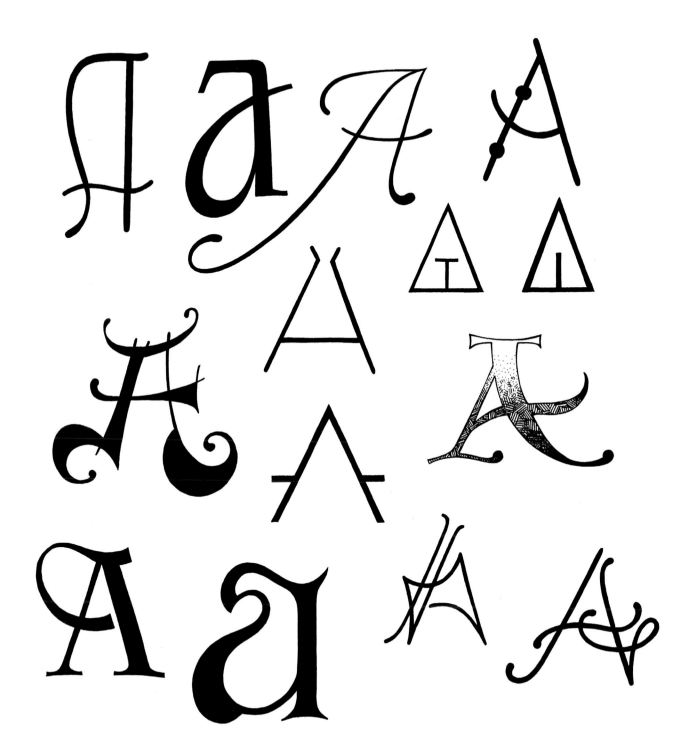

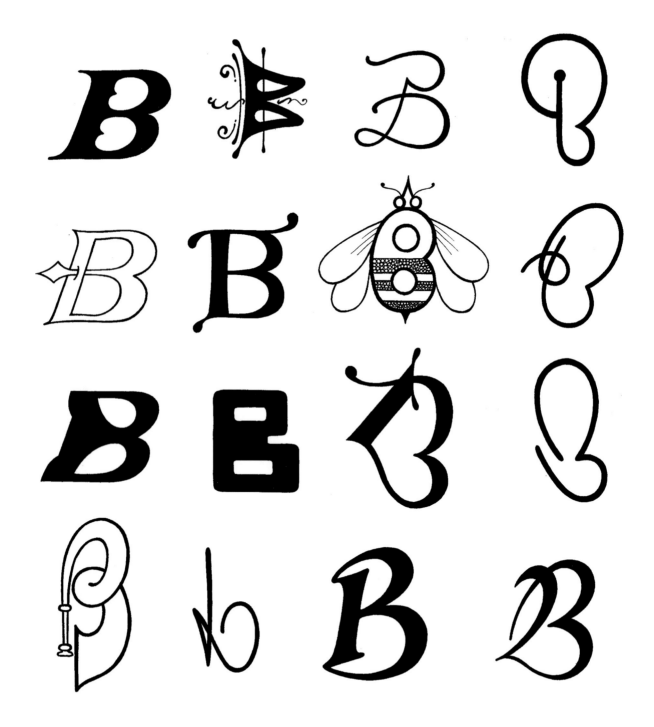

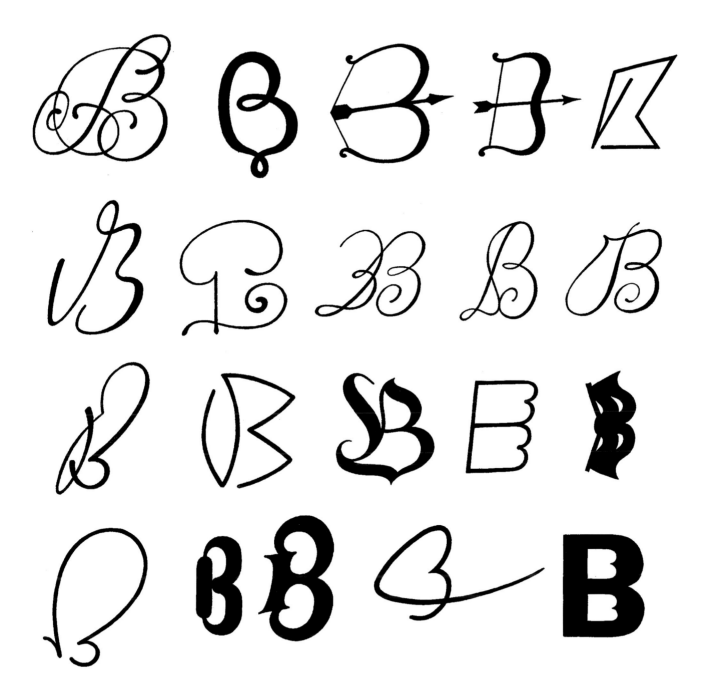

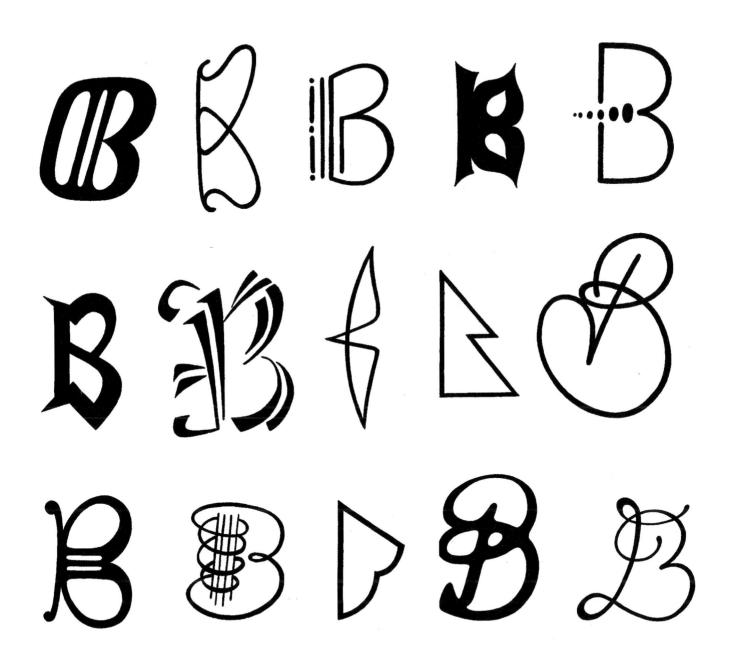

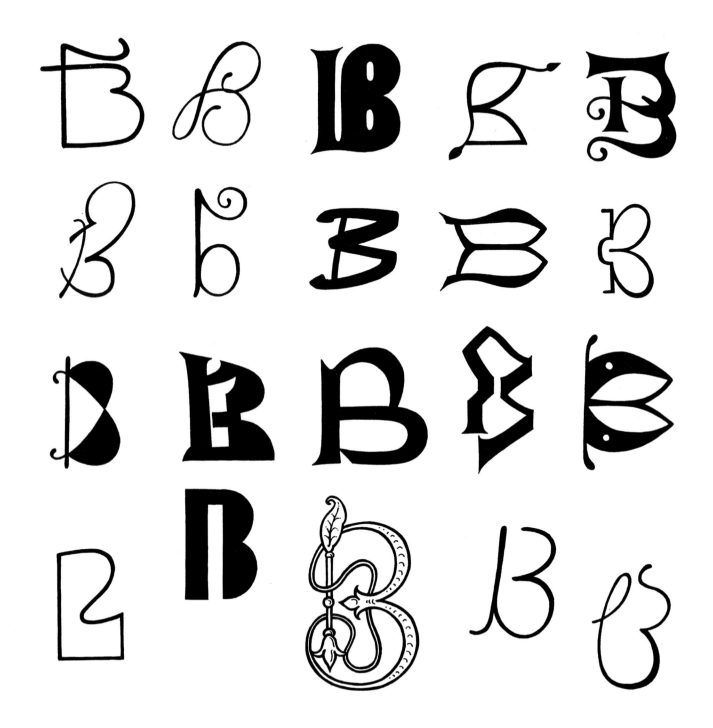

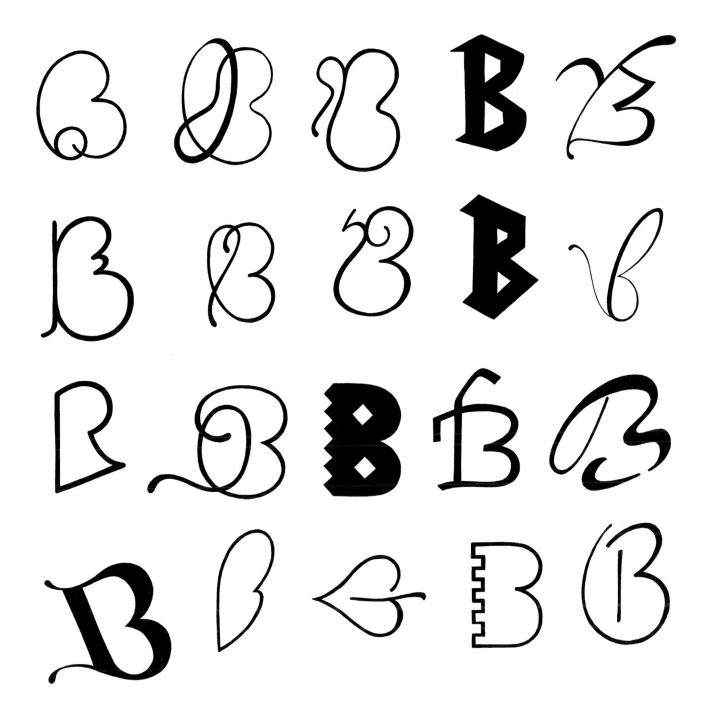

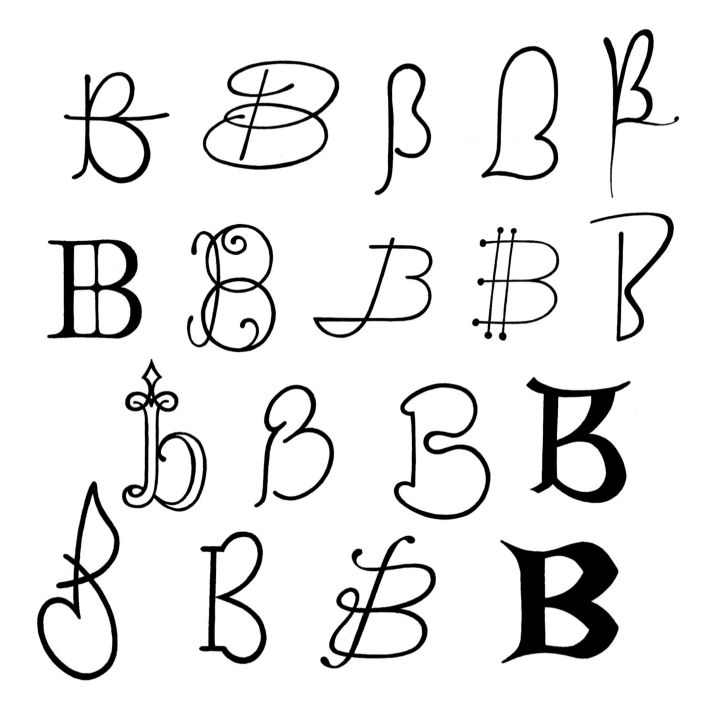

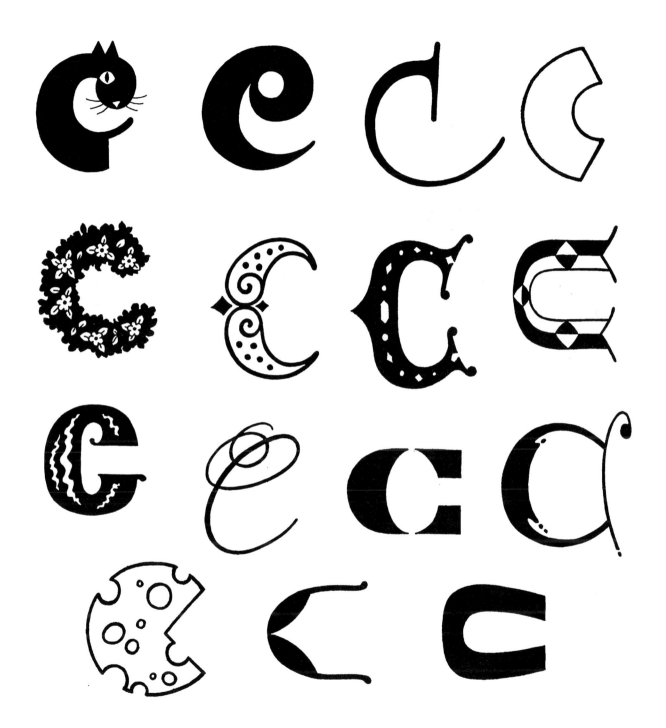

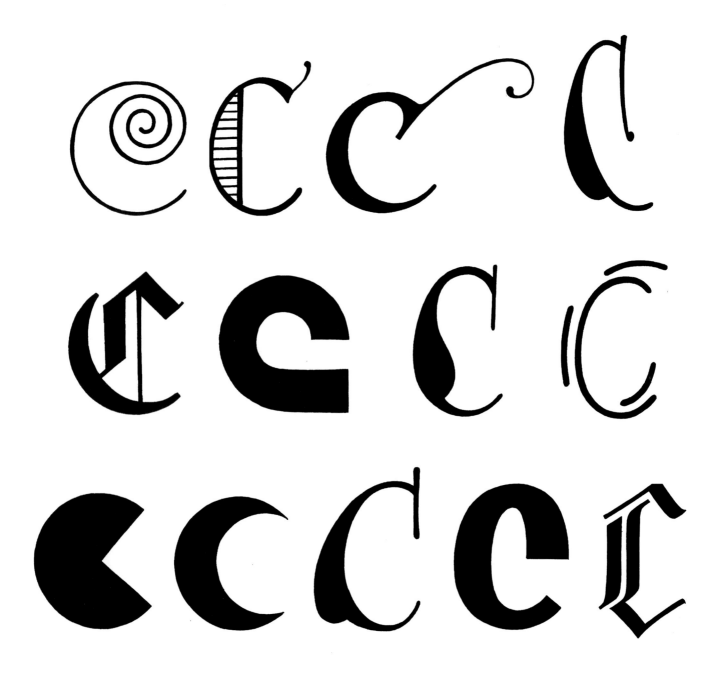

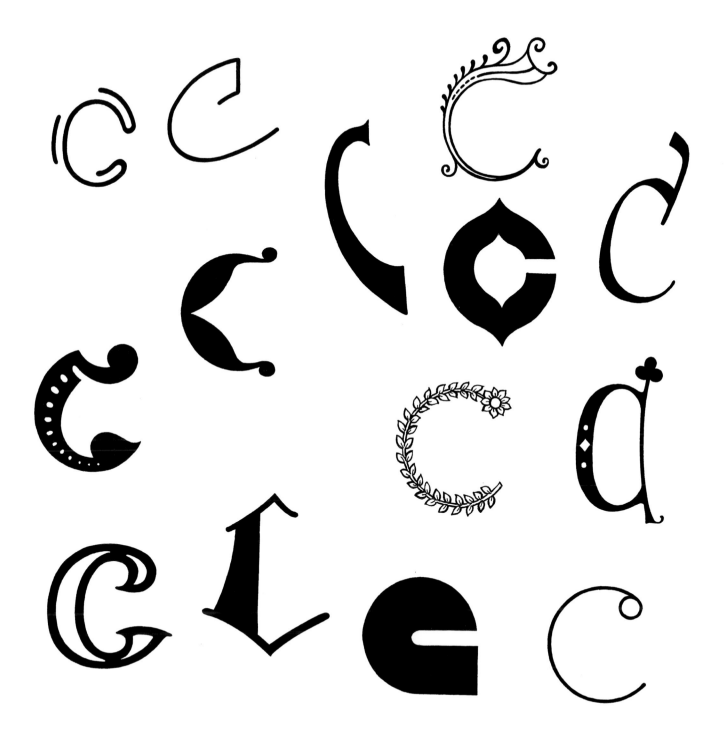

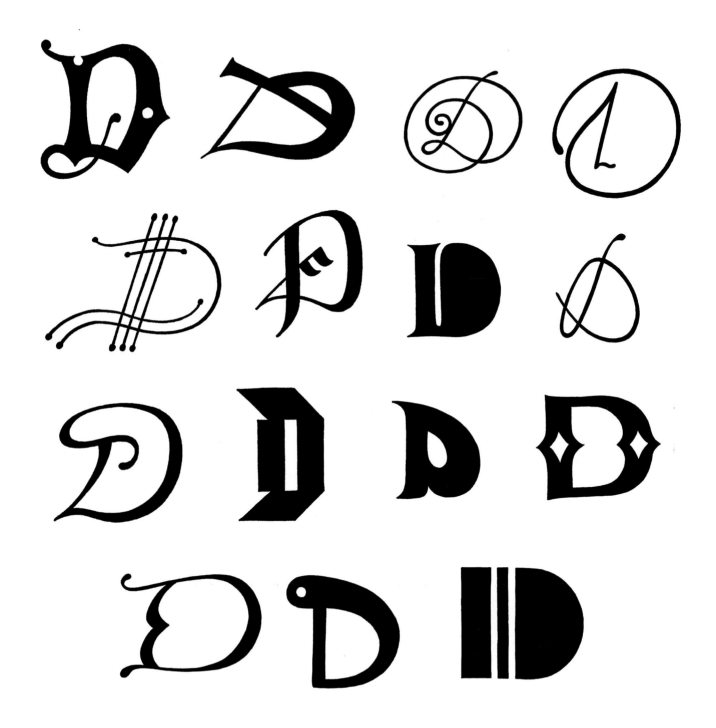

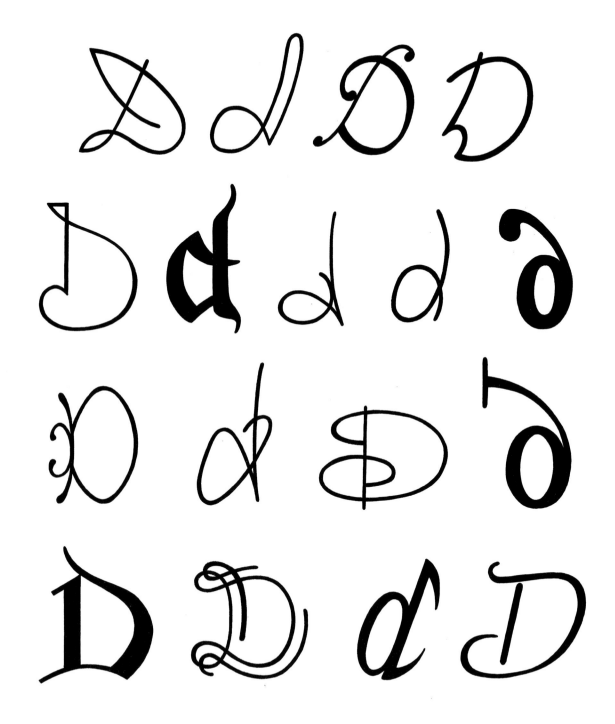

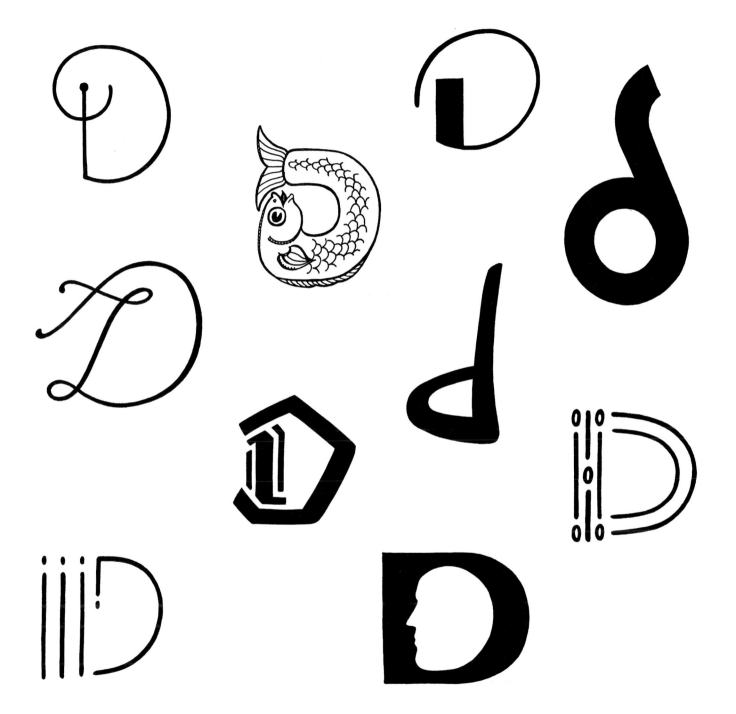

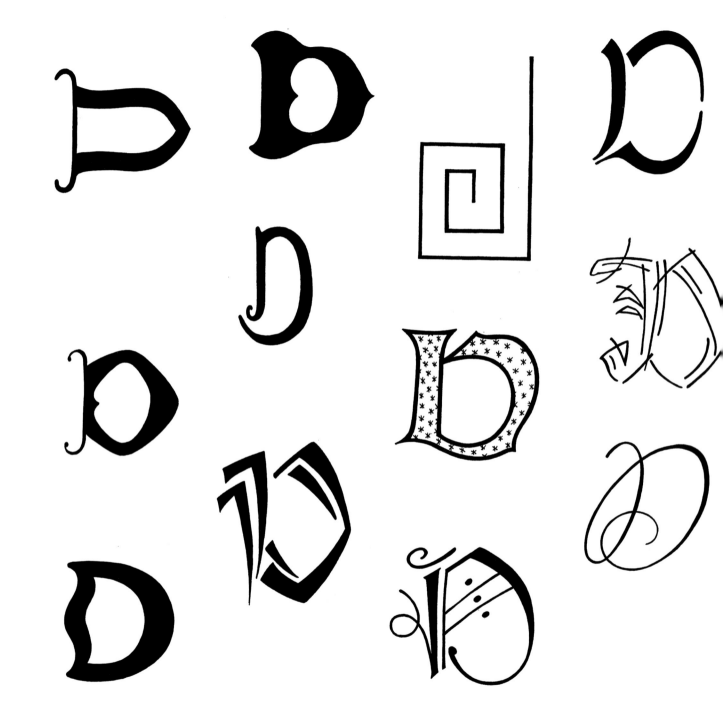

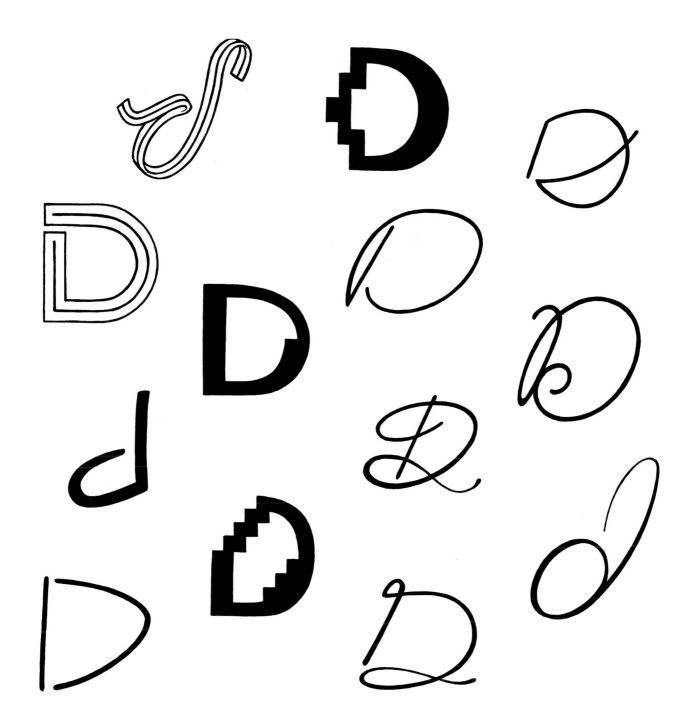

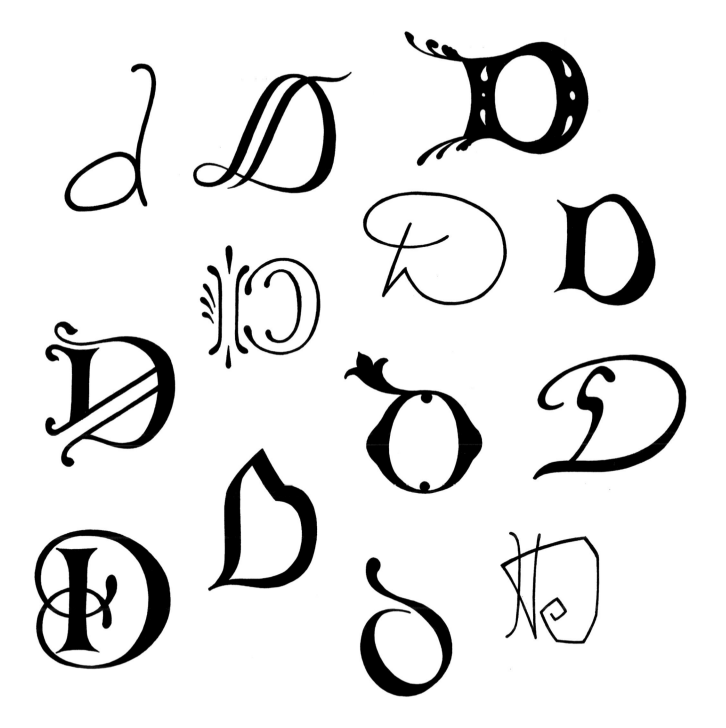

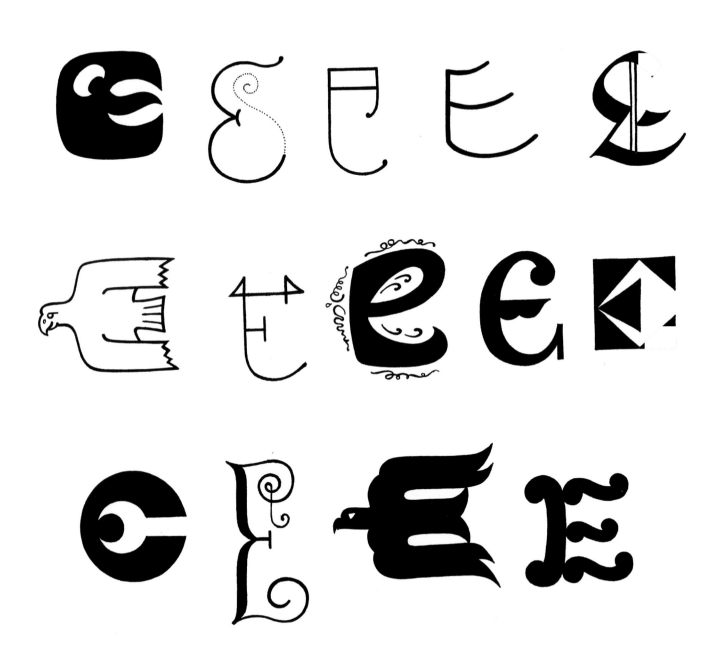

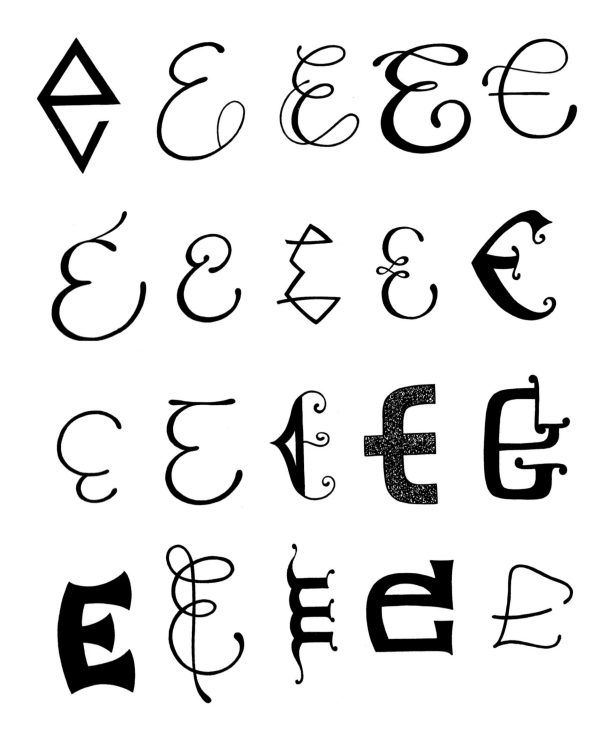

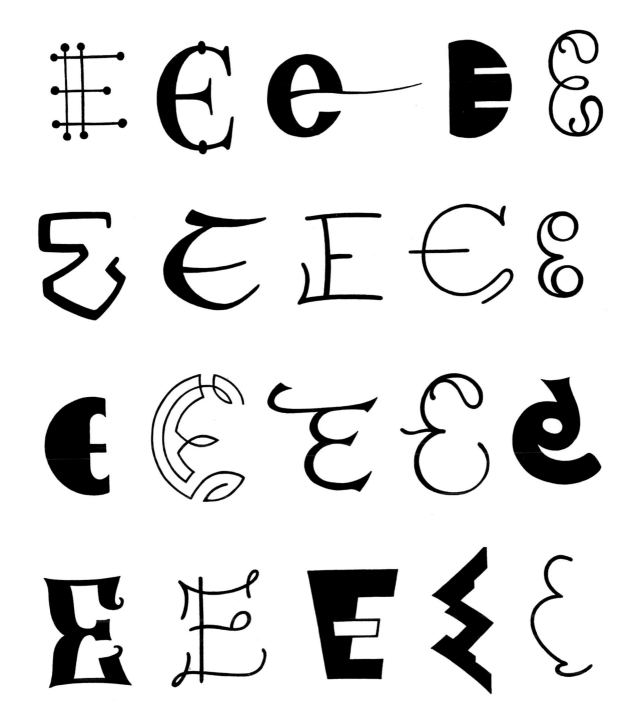

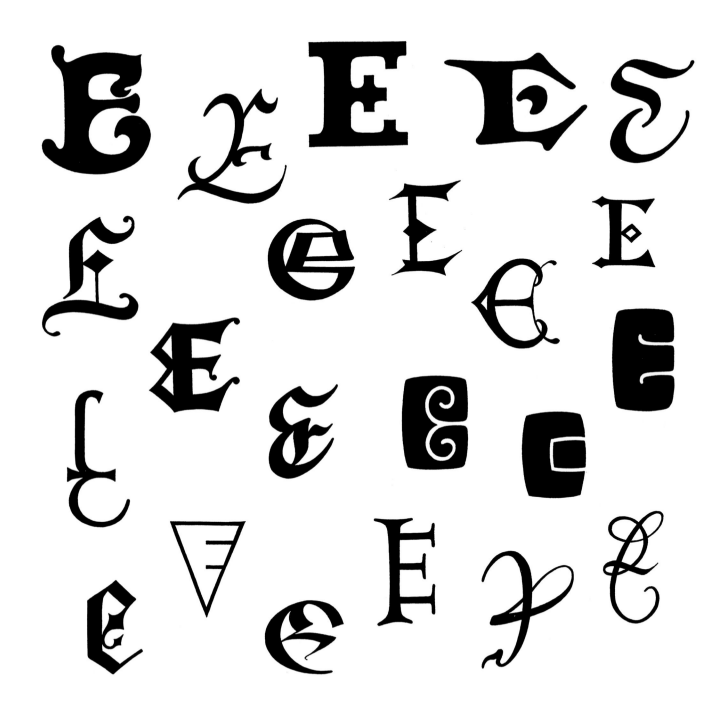

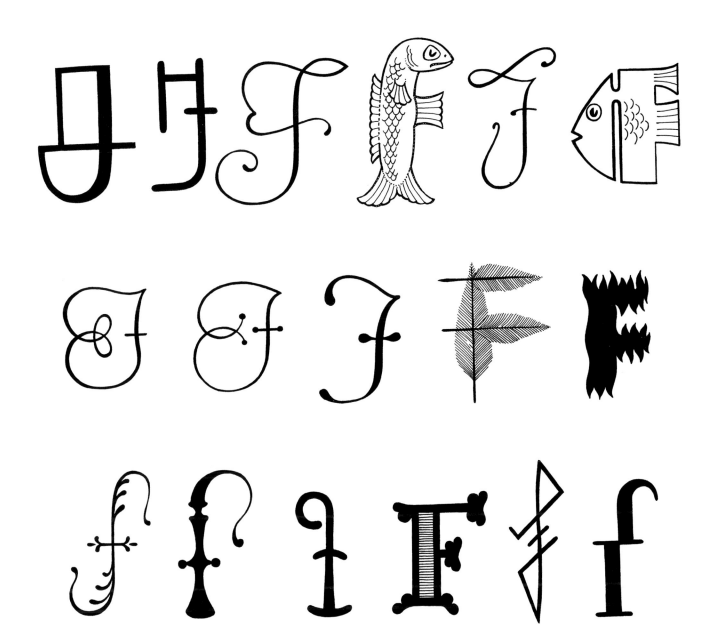

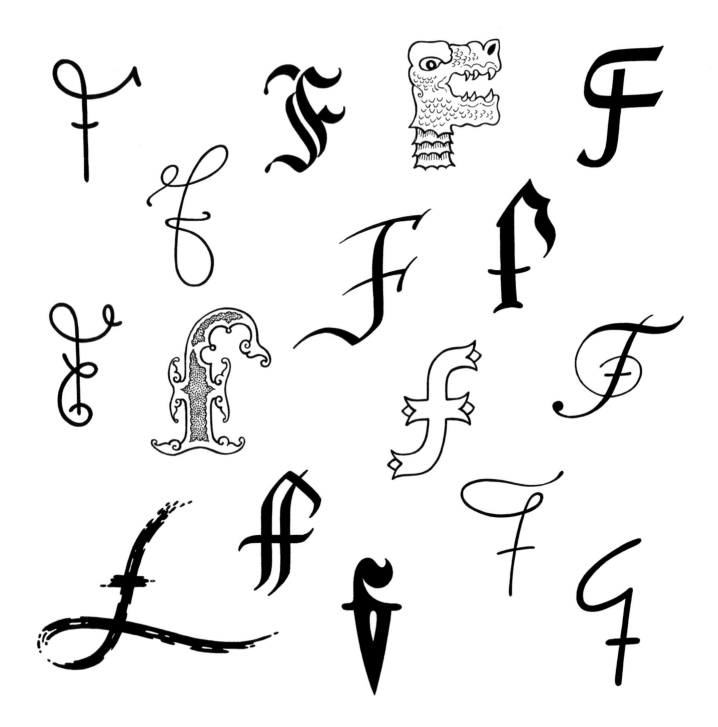

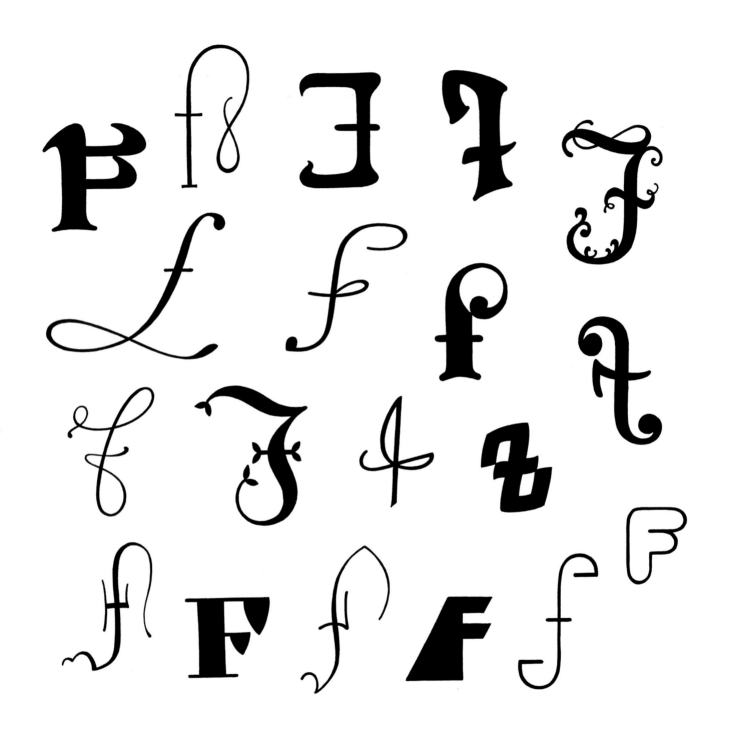

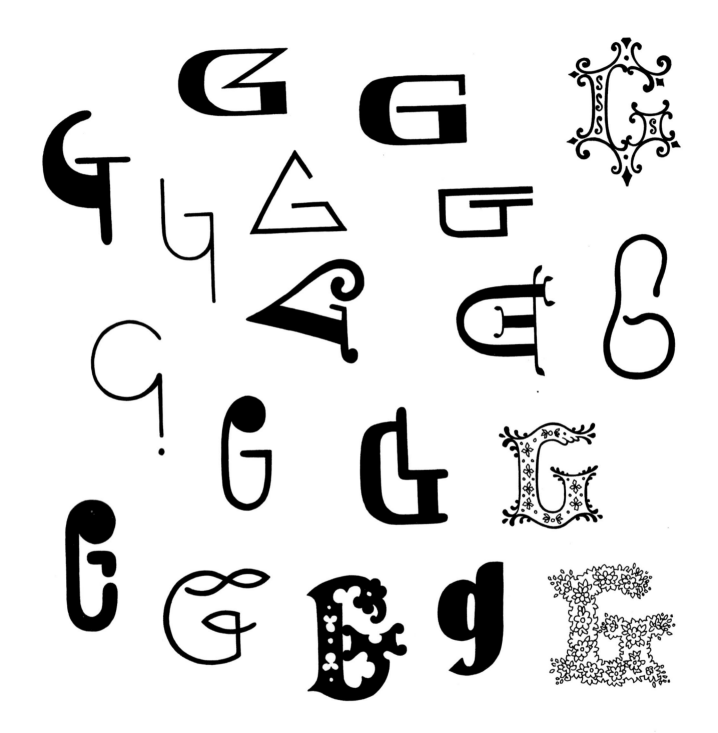

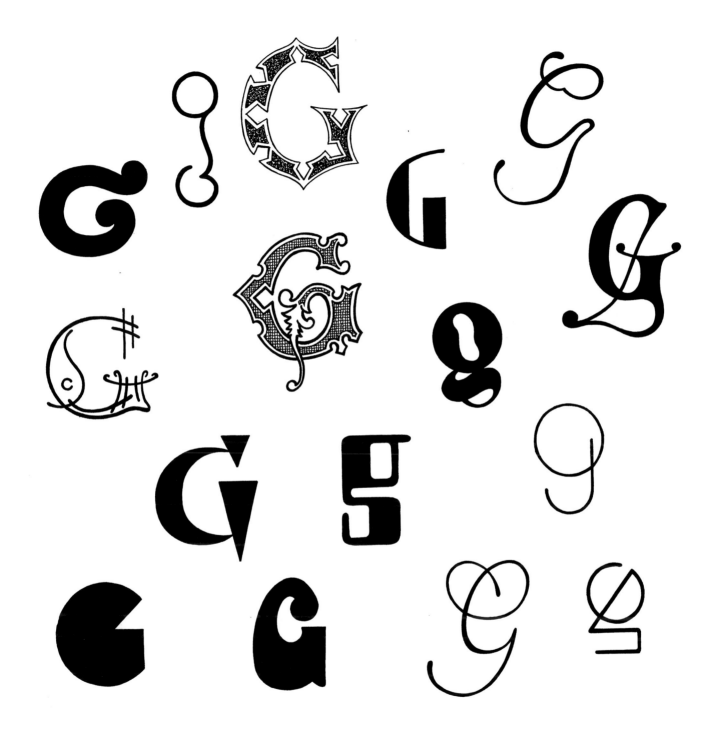

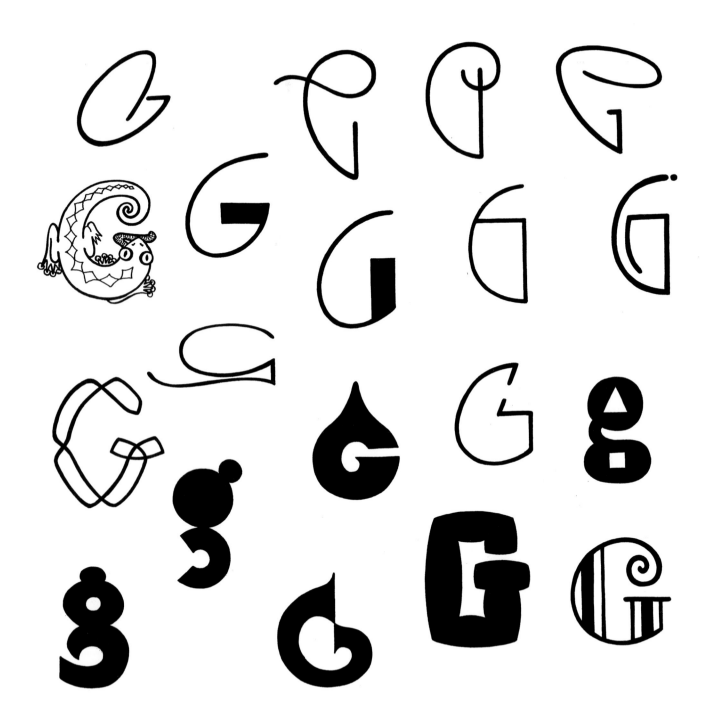

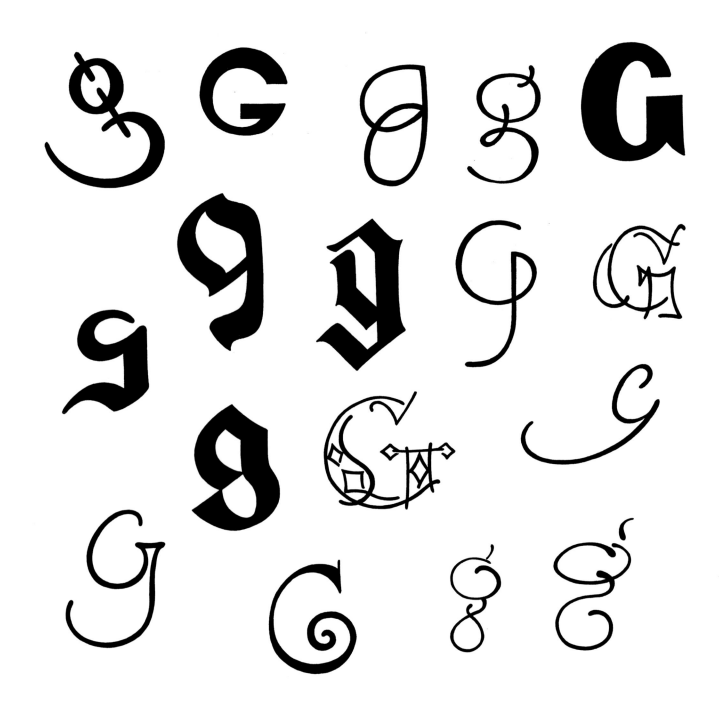

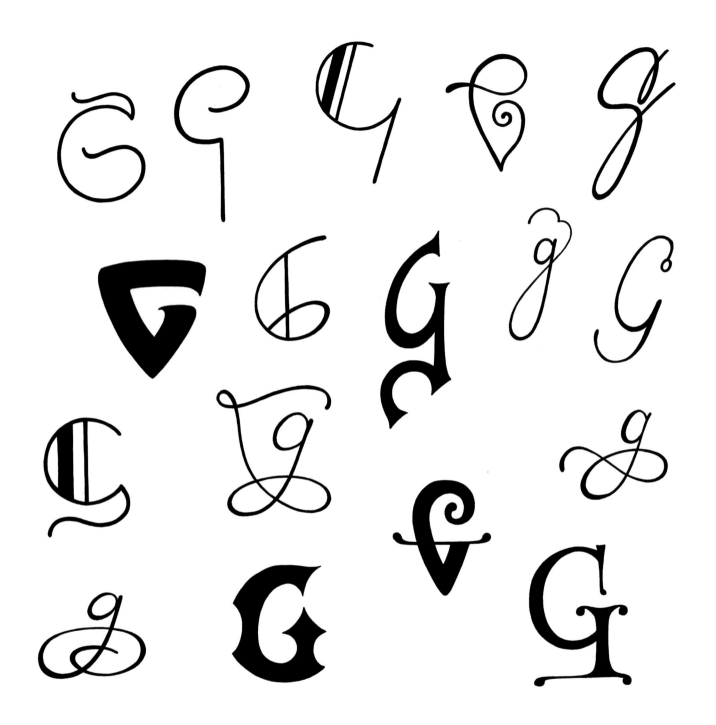

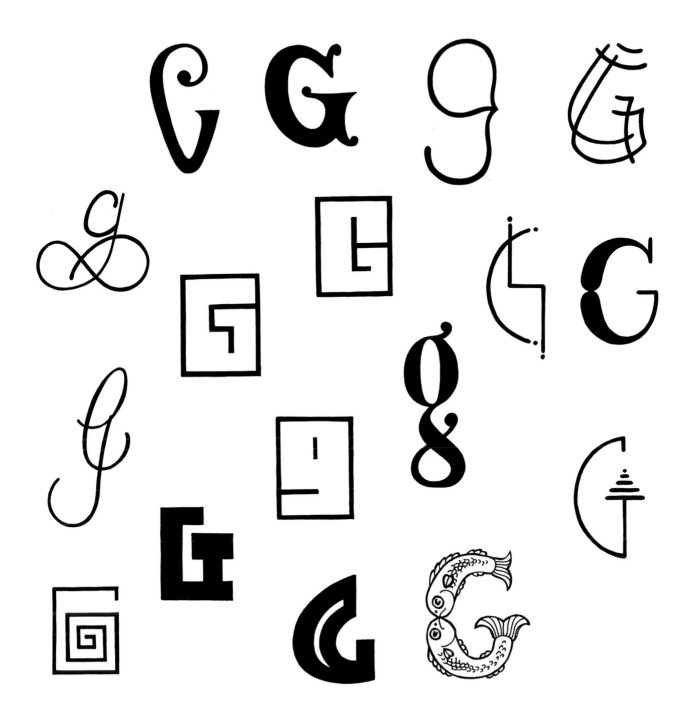

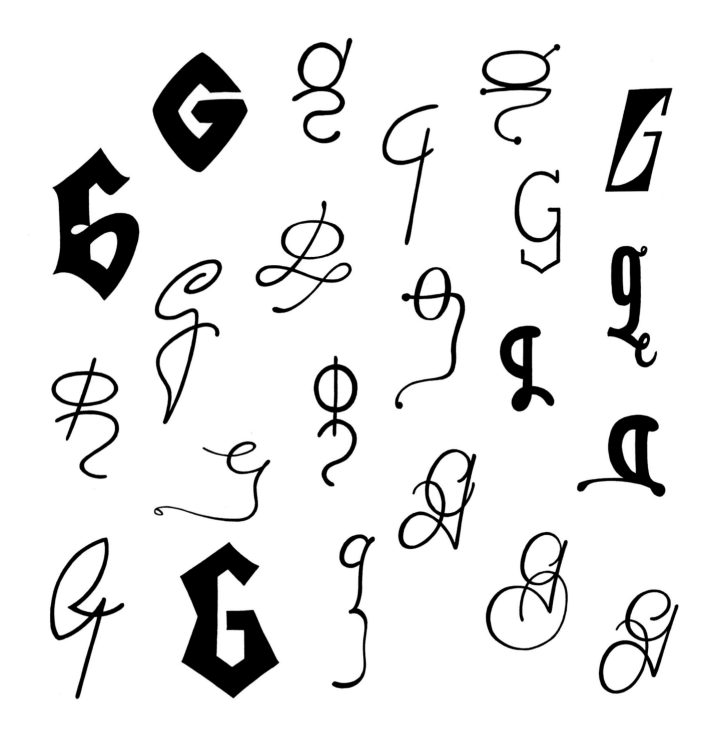

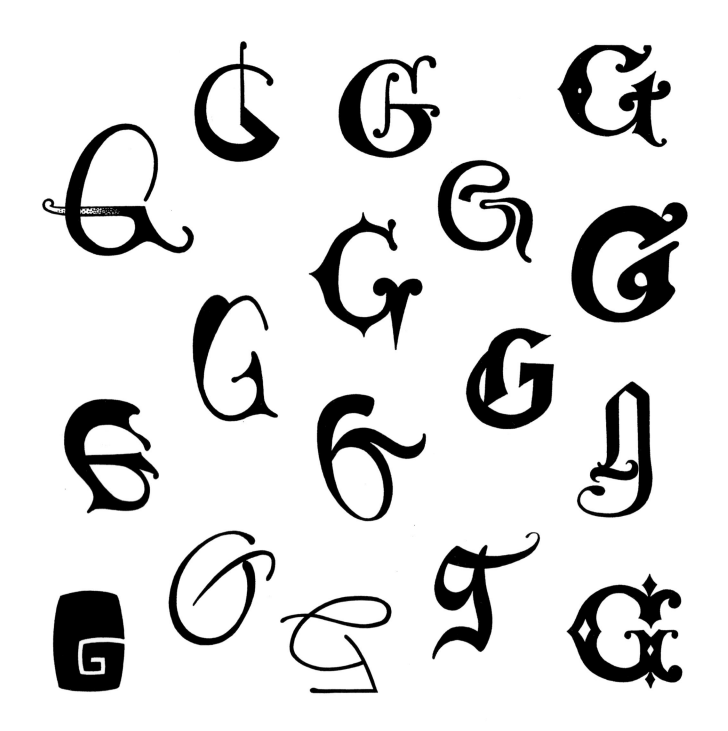

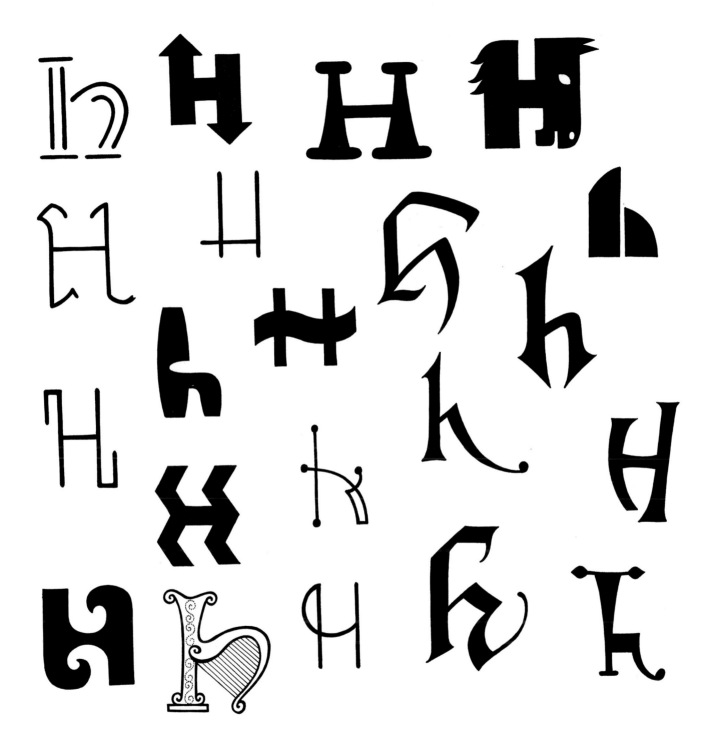

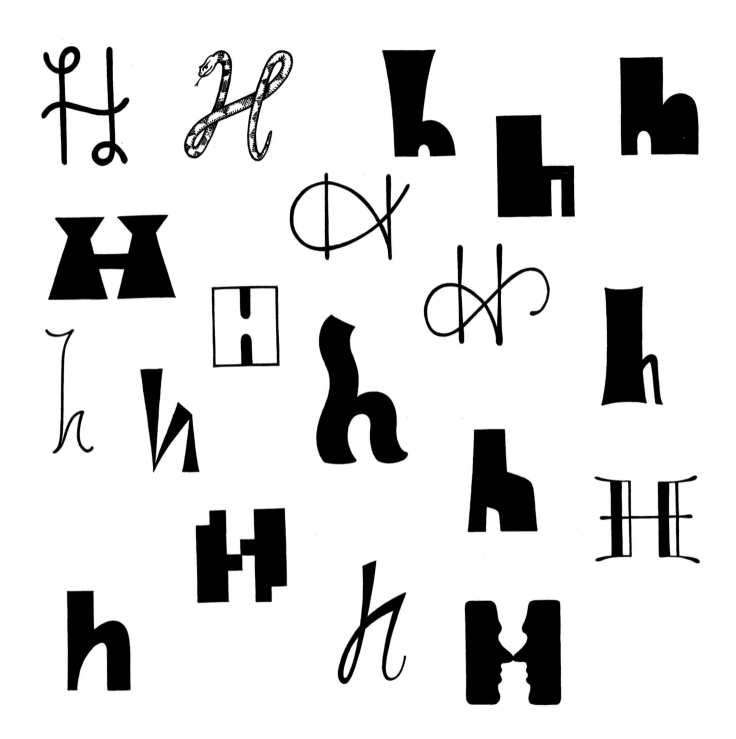

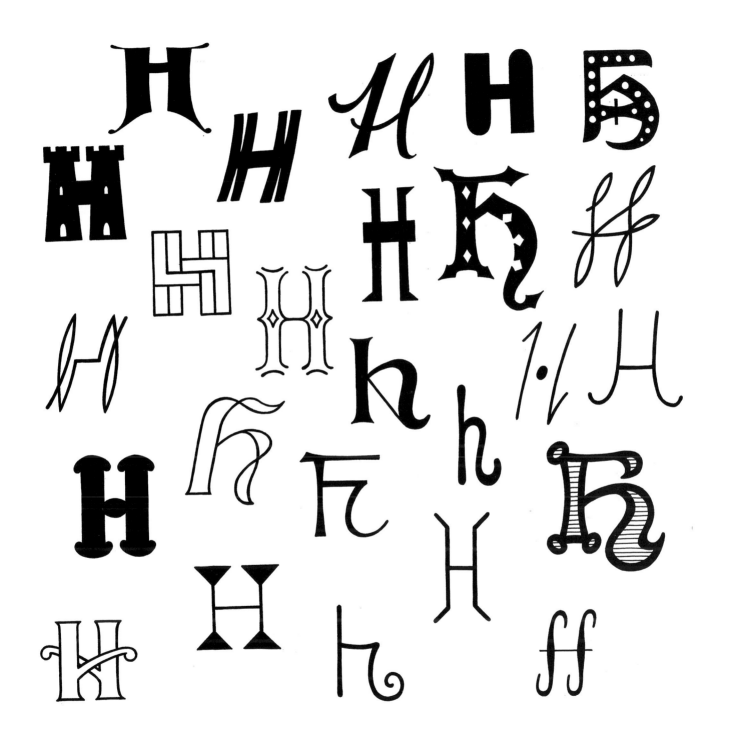

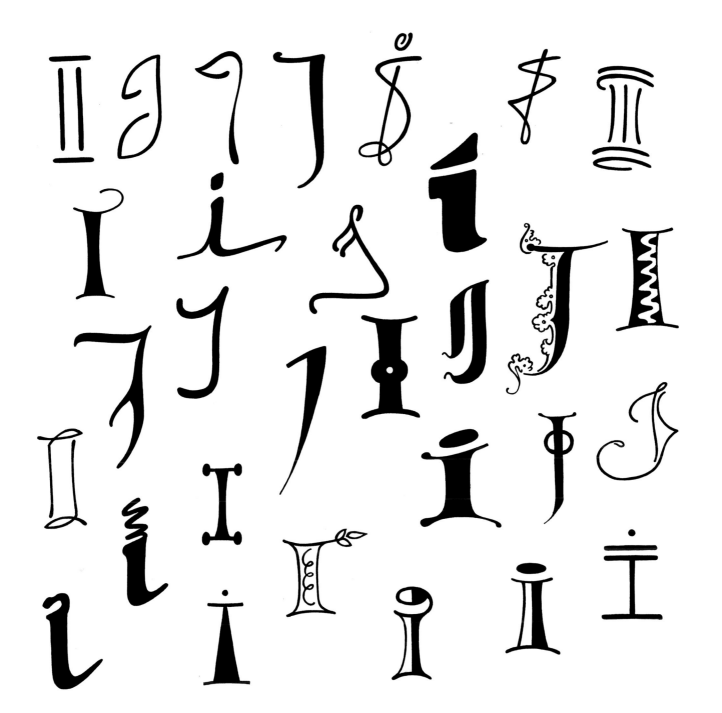

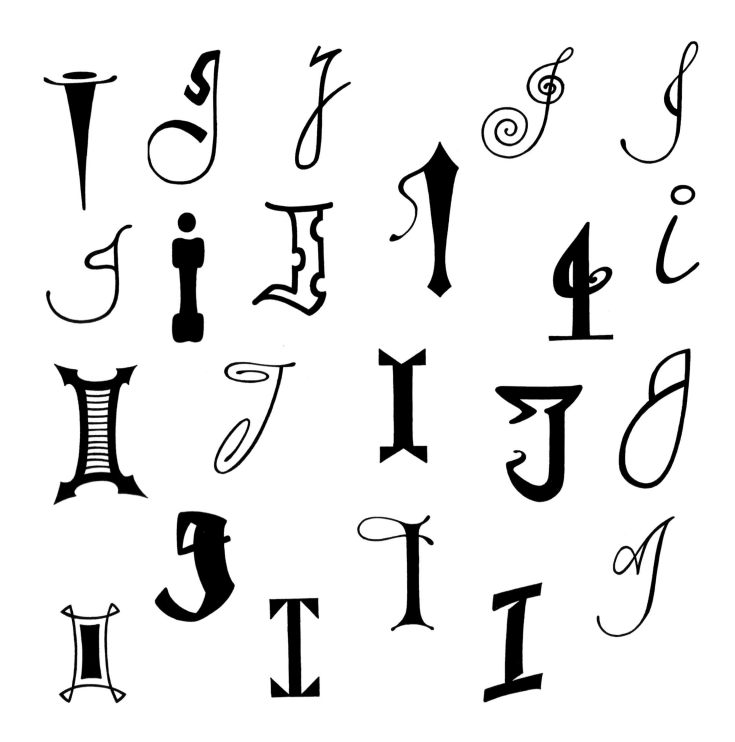

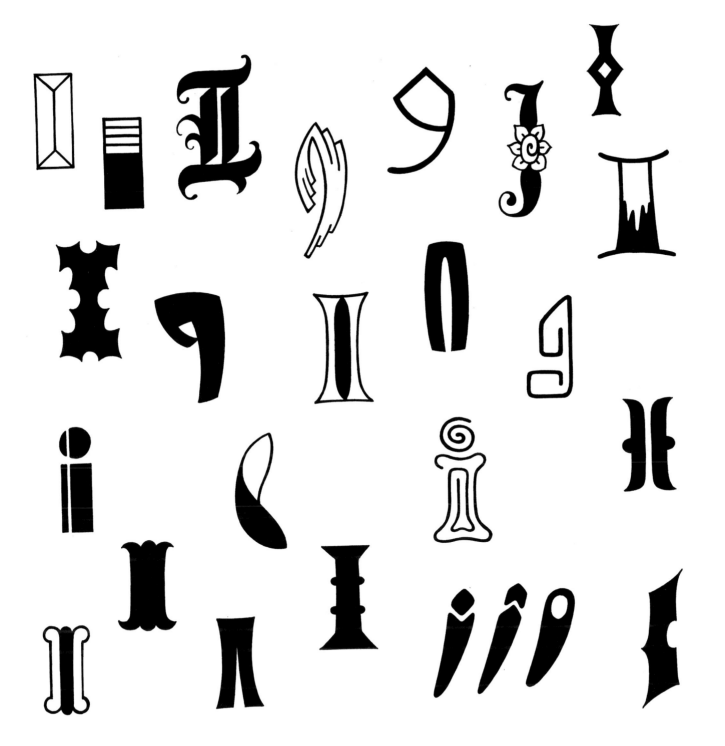

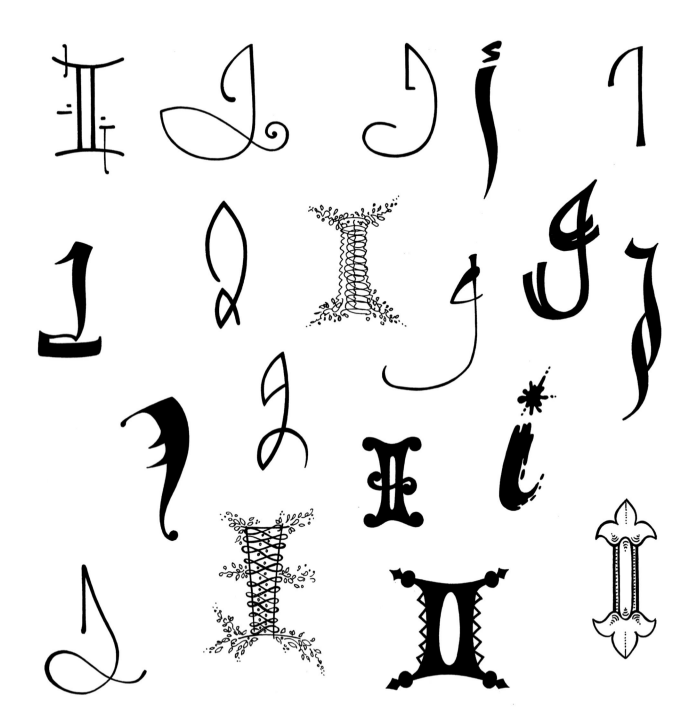

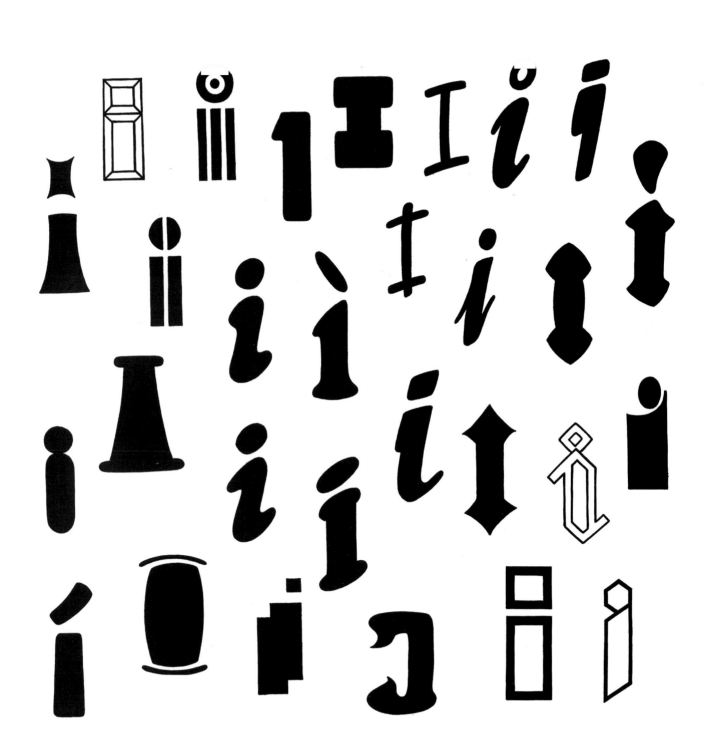

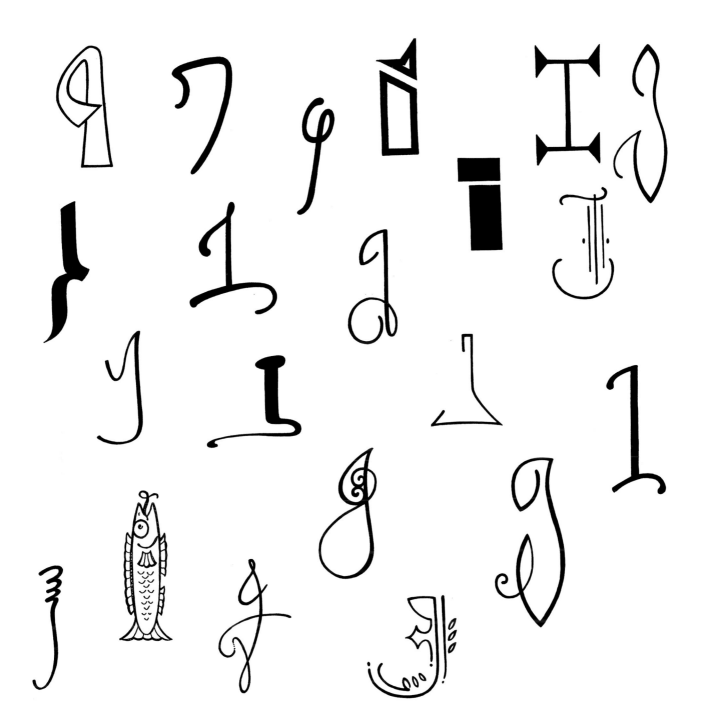

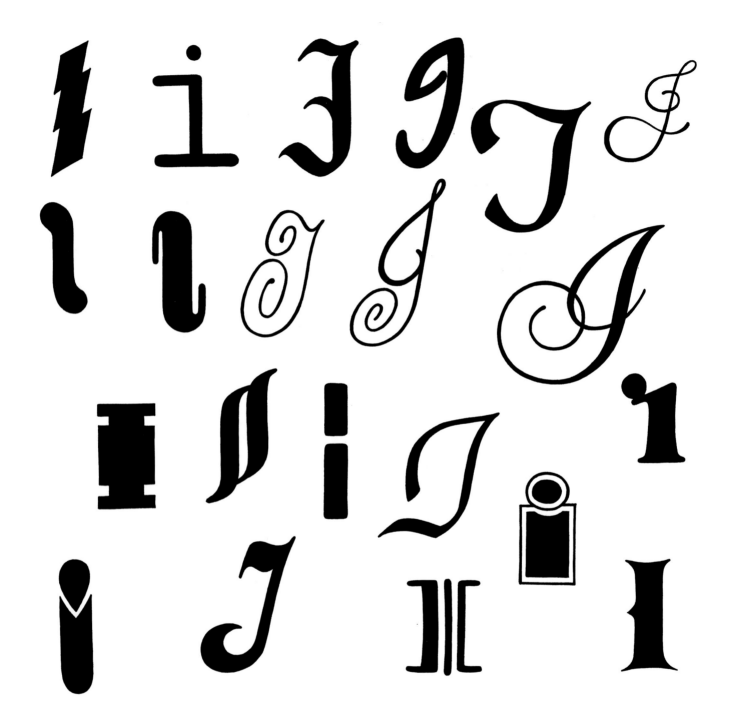

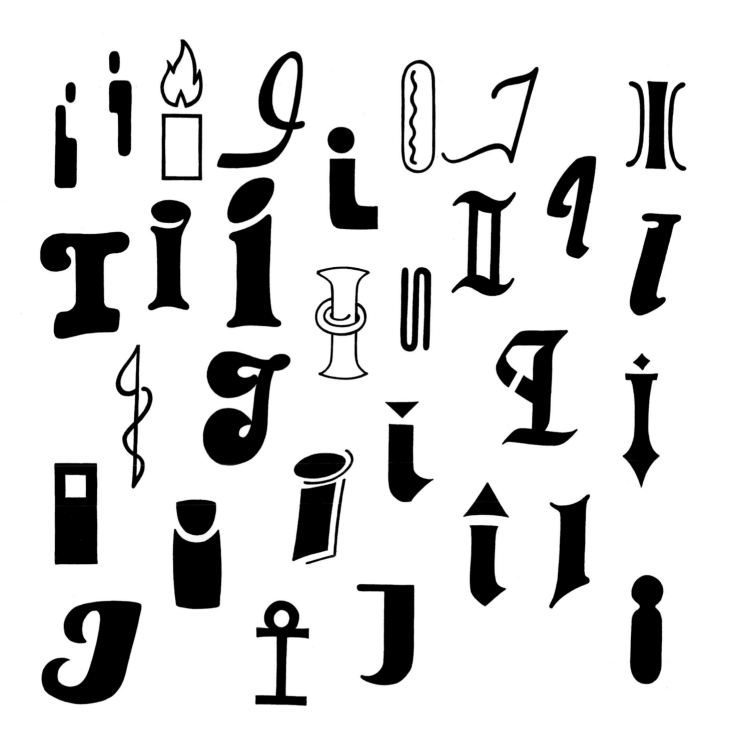

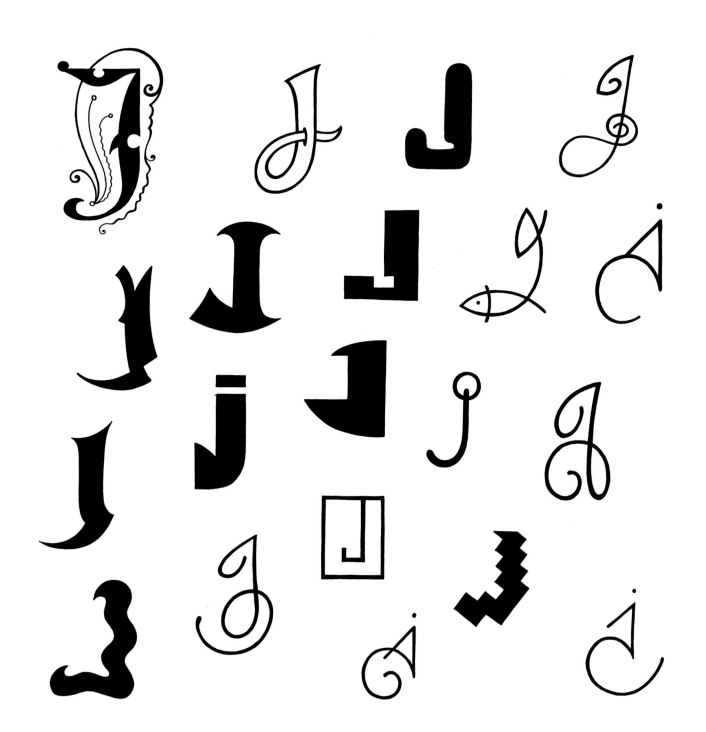

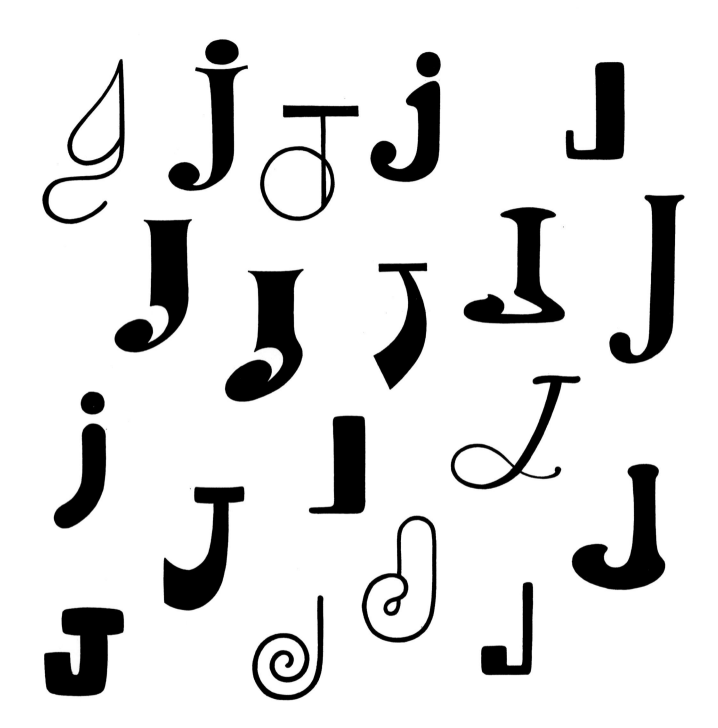

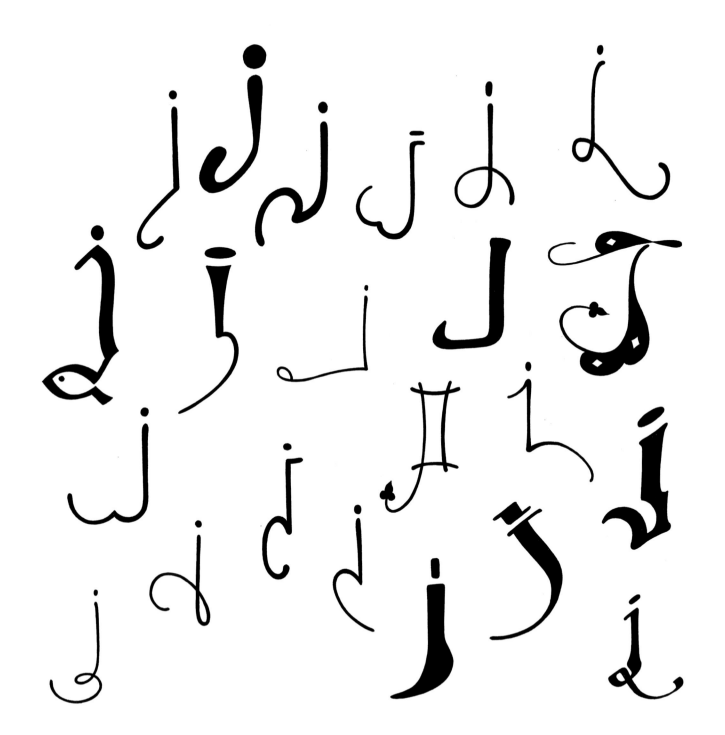

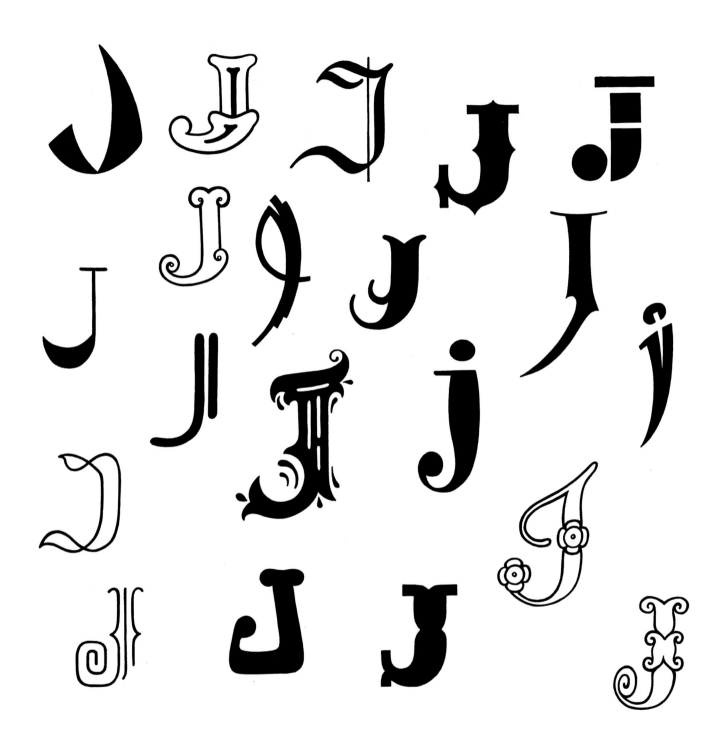

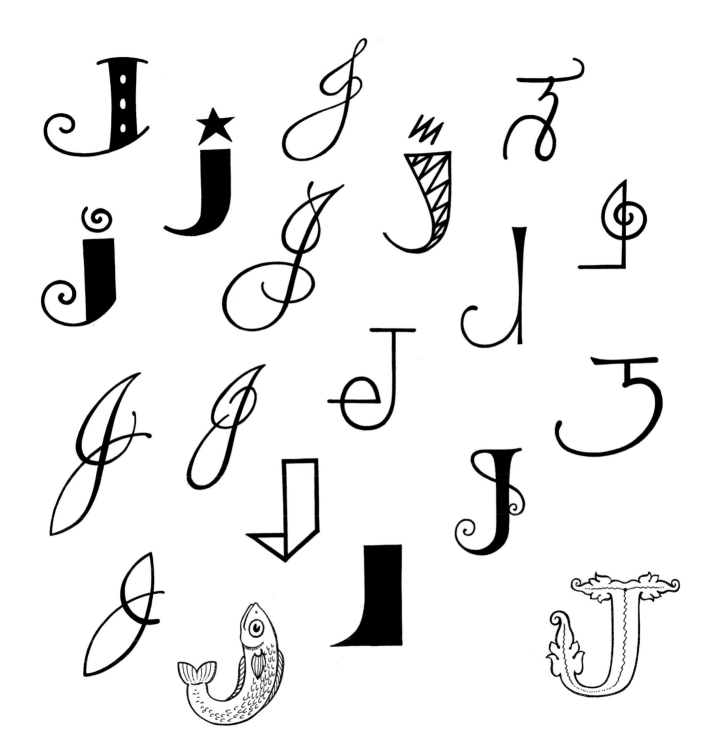

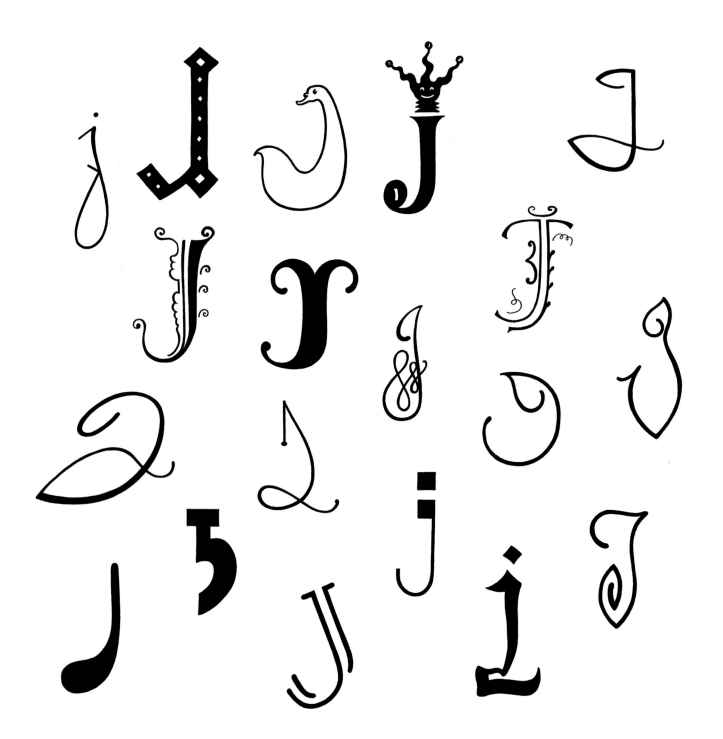

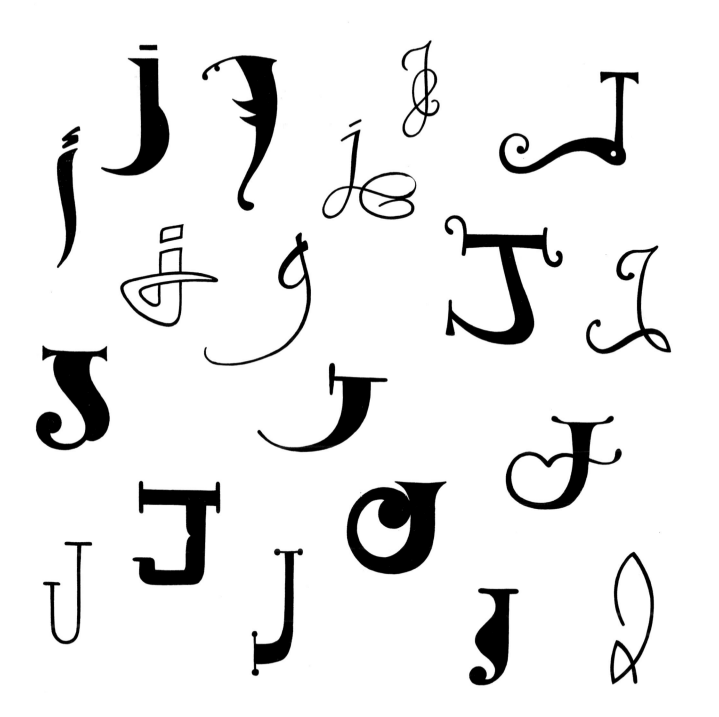

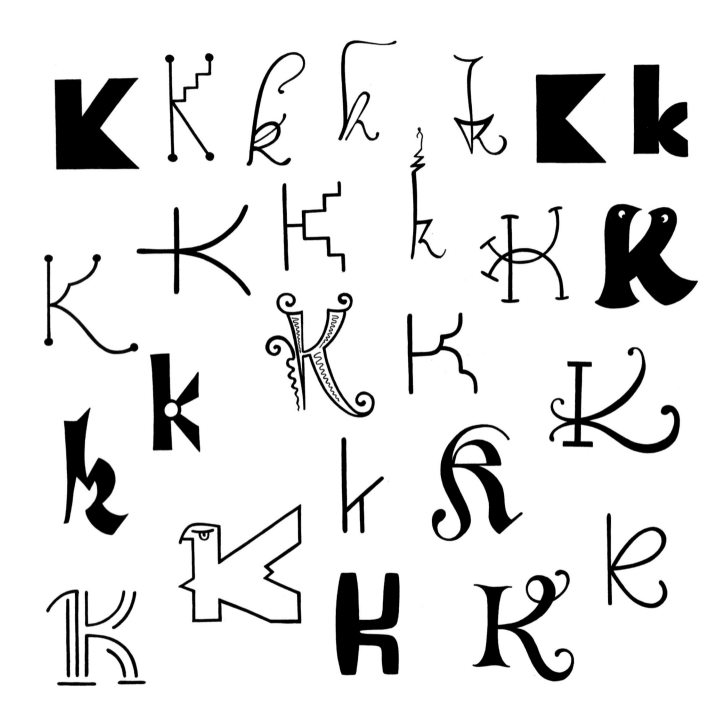

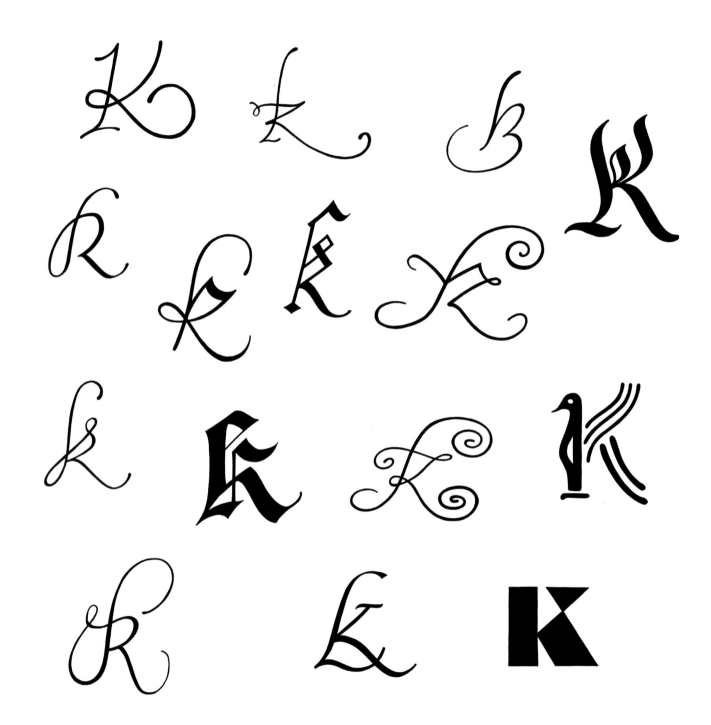

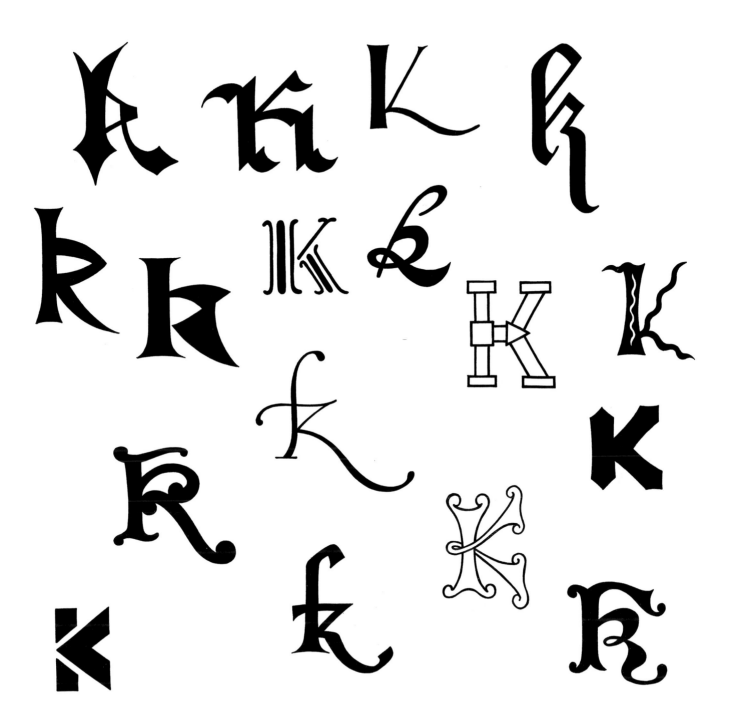

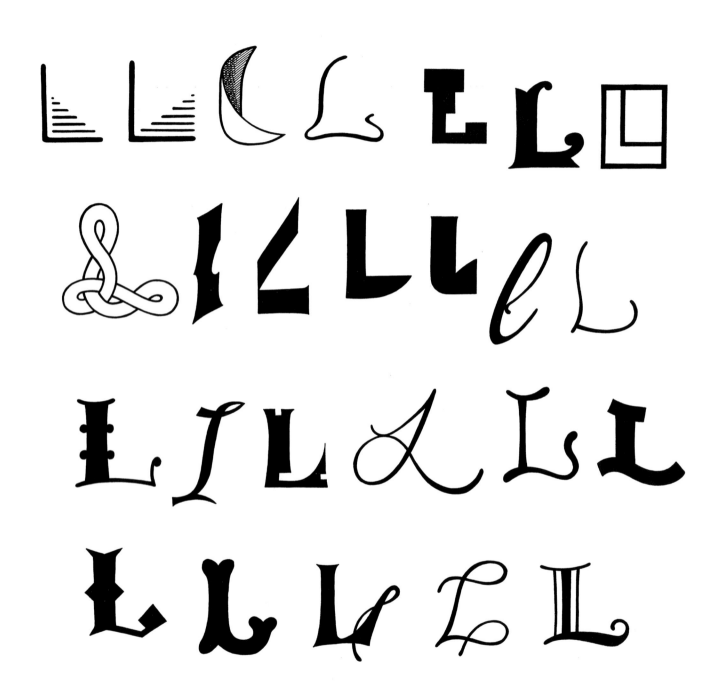

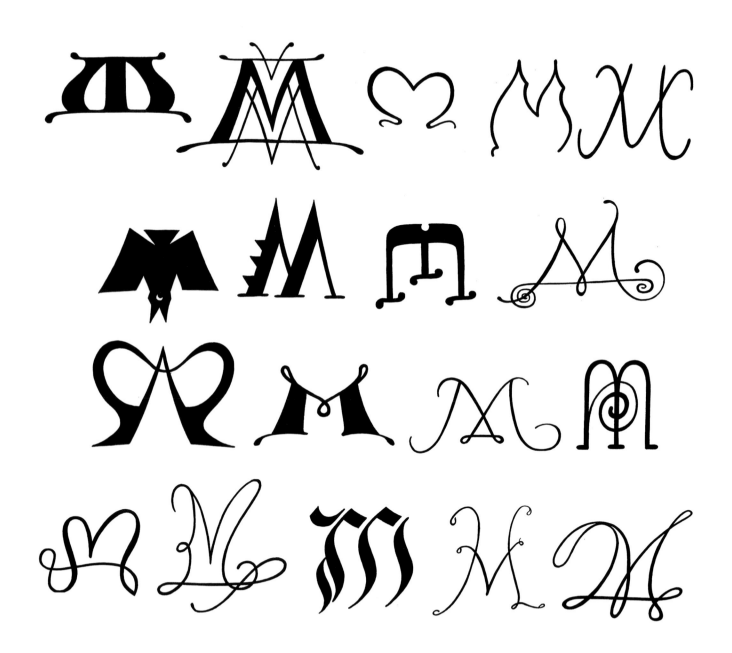

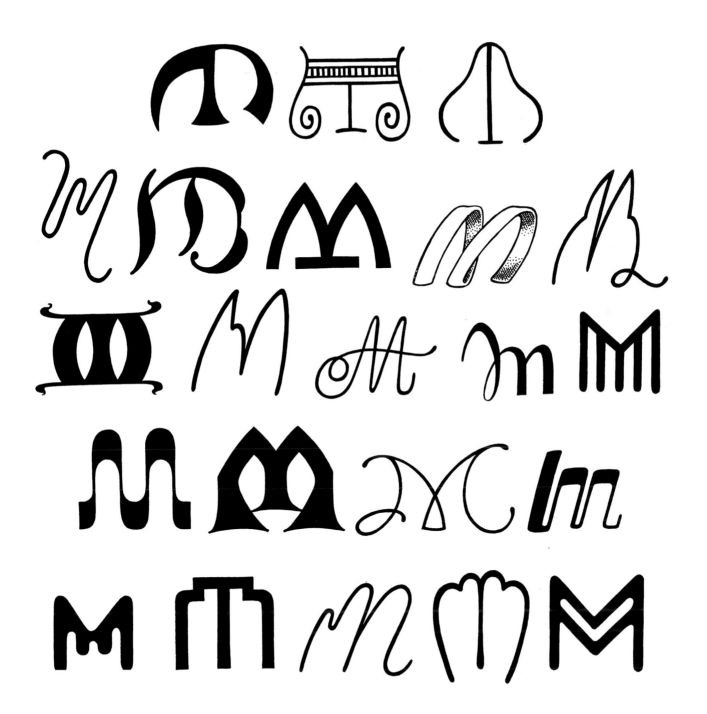

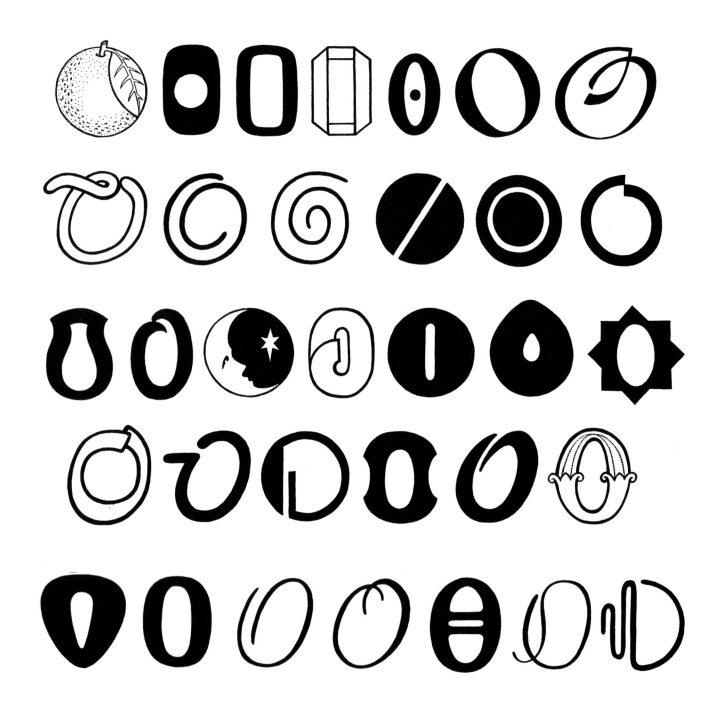

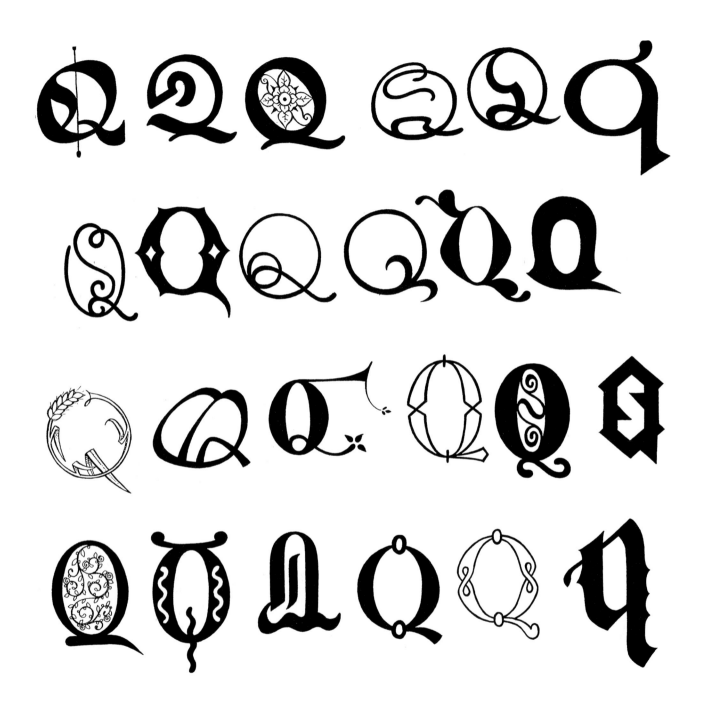

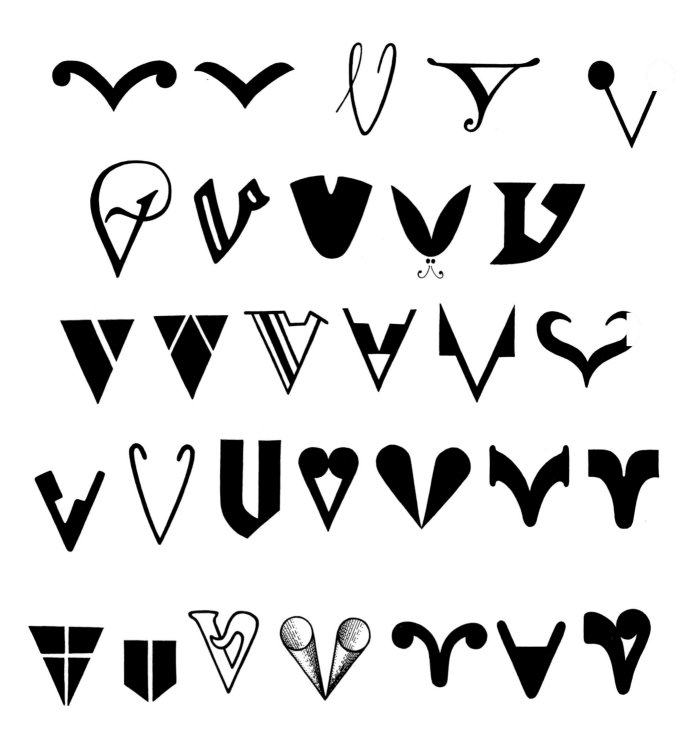

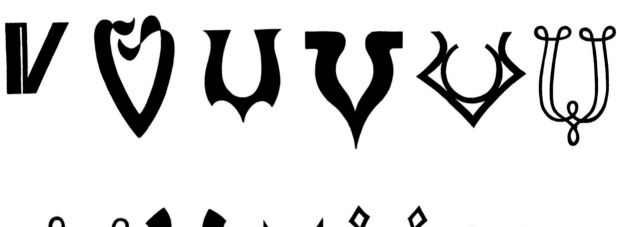

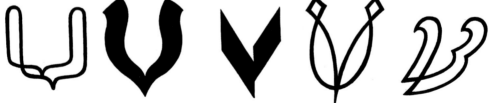

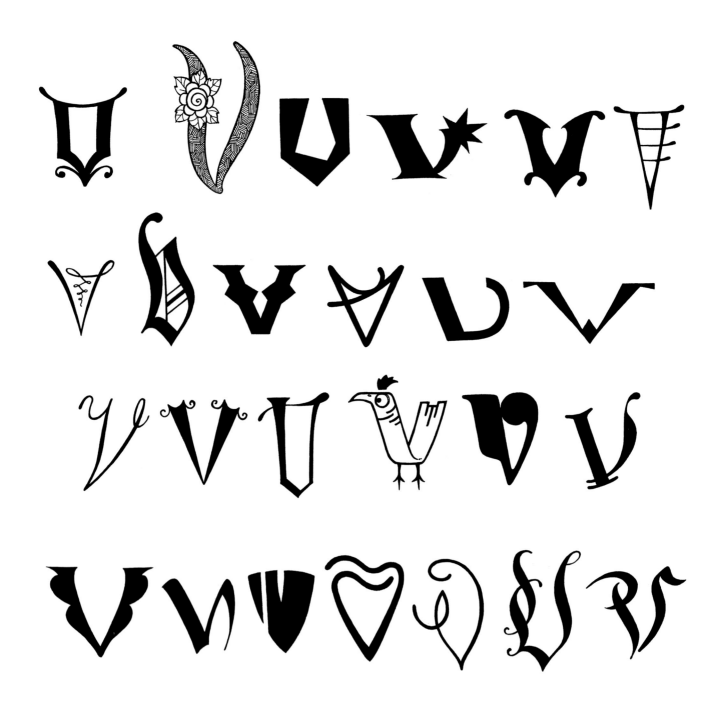

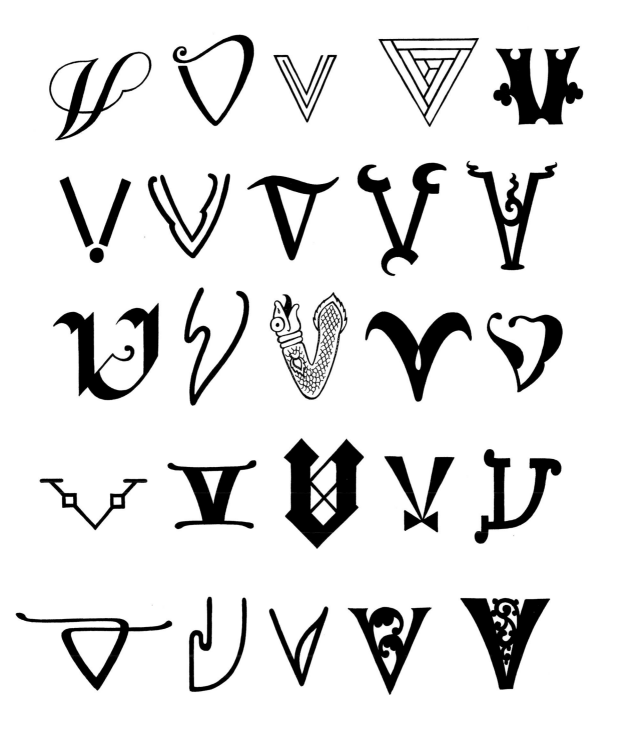

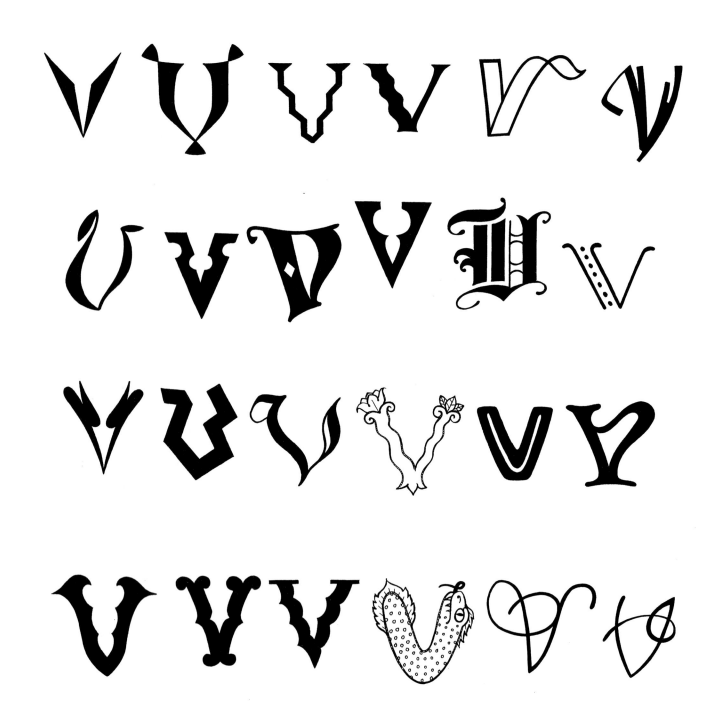

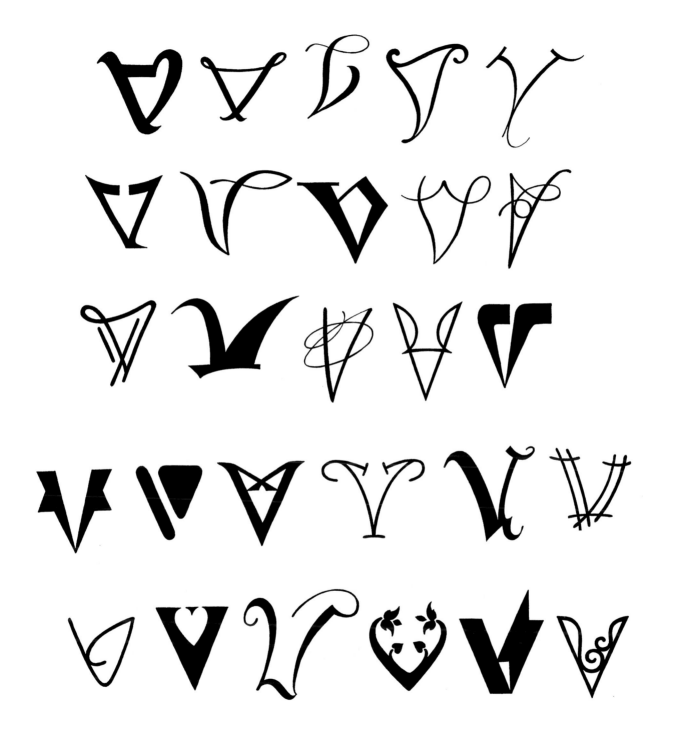

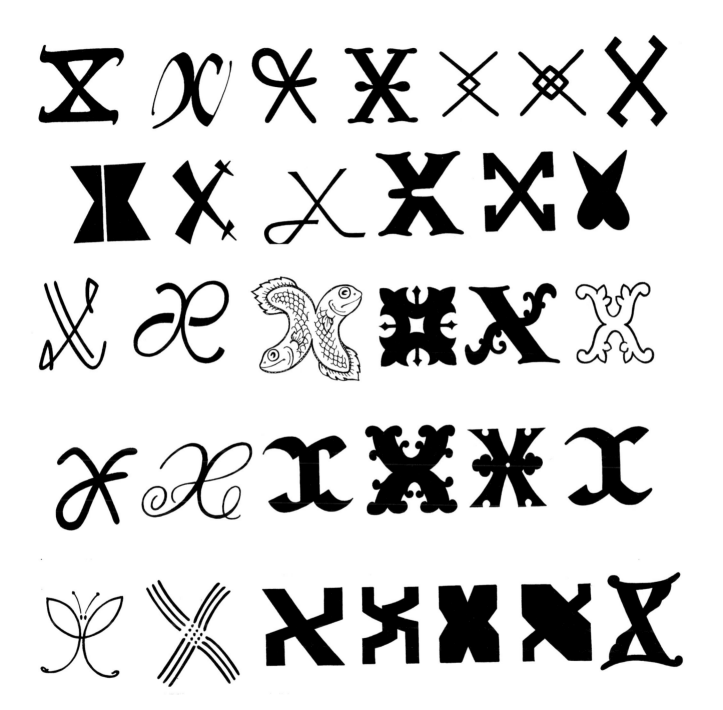